MAIDSTONE
THROUGH TIME
Irene Hales

AMBERLEY PUBLISHING

Acknowledgements

Most of the early illustrations in this book are from my collection of postcards and photographs, but I would like to thank Kay and Eric Baldock for the loan of some of their local cards and Brenda Sharp for the photograph of Foley House. I also wish to thank Eric for photographing the coloured modern views and David Frazer, my grandson, for typing the manuscript.

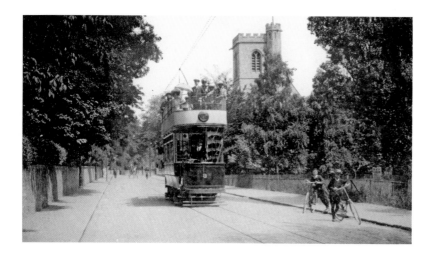

First published 2009

Amberley Publishing Plc
Cirencester Road, Chalford,
Stroud, Gloucestershire, GL6 8PE

www.amberley-books.com

Copyright © Irene Hales, 2009

The right of Irene Hales to be identified as the
Author of this work has been asserted in accordance
with the Copyrights, Designs and Patents Act 1988.

ISBN 978 1 84868 640 3

British Library Cataloguing in Publication Data.
A catalogue record for this book is available from
the British Library.

Typeset in 9.5pt on 12pt Celeste.
Typesetting by Amberley Publishing.
Printed in the UK.

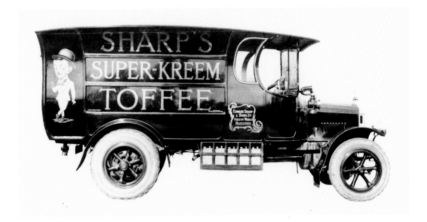

Contents

Introduction

In the Middle Ages Maidstone was dominated by the church and came under the jurisdiction of the Archbishop of Canterbury. The collegiate Church of All Saints', the adjacent college and Archbishop's Palace were built for the Archbishops in the fourteenth century. This fine group of buildings on the riverside at Maidstone are still there for us to enjoy. Maidstone grew into a prosperous market town in the area known as the Garden of England. Orchards and hop gardens, with their accompanying oast houses, skirted the town. Much of the hops and fruit were transported on the River Medway to the London markets. Some of the hops were sent to the four local breweries, the Lower Brewery, the Medway Brewery, Fremlin's and Mason's. With four breweries in the town they encouraged public houses to open, and a century ago Maidstone possessed more than one hundred inns and taverns. Maidstone also boasted several important industries including papermaking, vehicle manufacture, agricultural implements, food and confectionary. Electricity was introduced to the town in 1901. Gas and the railway had already reached Maidstone during the previous century, when horse power had prevailed. In the twentieth century the motorcar made its appearance, while carrier carts were replaced by lorries. The first trams were inaugurated in 1904, soon followed by motor-buses and later trolleybuses.

This century Maidstone has changed beyond recognition with its high-rise flats and congested roads. The population has increased from 14,000 to more than 130,000 and housing has mushroomed accordingly. We now have motorways, undercover shopping precincts, night clubs and bingo halls, but is Maidstone a better town than it used to be?

Most of the early photographs in this book were produced approximately one hundred years ago from picture postcards. They reveal a way of life that is now hard to imagine. High praise indeed for the early photographers who were out and about with their plate cameras taking local views and events. Of those Maidstone photographers whose work can be identified were the partners Young & Cooper and De'ath & Dunk. These plate cameras produced very sharp images almost as good as the digital cameras of today. This book includes some of these digital photographs, highlighting in colour the many alterations in the town today. For comparison, they have been taken as closely as possible from the same viewpoints as the earlier photographs.

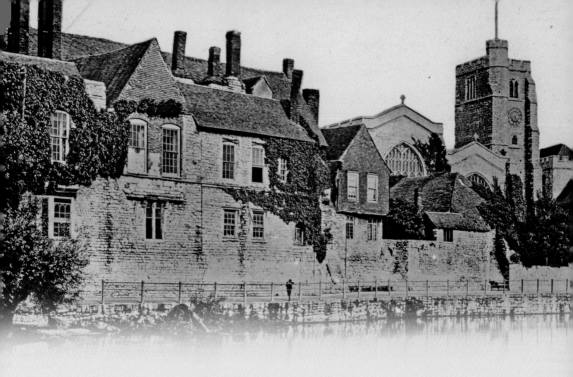

chapter 1

Medieval Maidstone

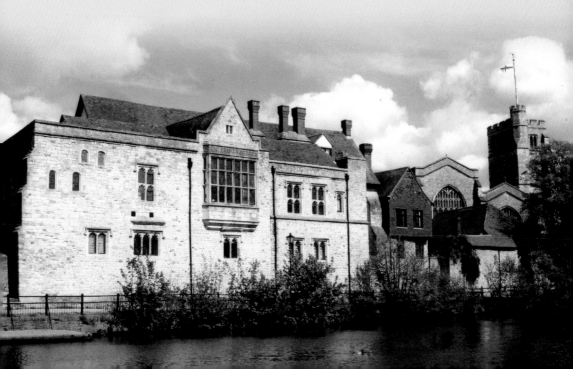

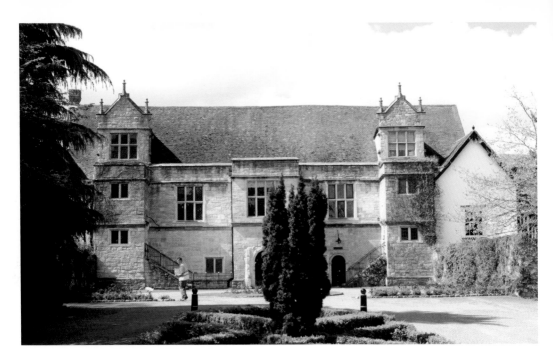

The Archbishop's Palace

The Archbishop's Palace, Mill Street, is now Maidstone's registry office and is also used for weddings and conferences. The palace dates back to 1348 and belonged to the Church until 1537. At different periods it was owned by Sir Thomas Wyatt, the Astley family (who added the Elizabethan front) and Lord Romney. By 1887 the palace had fallen into decay, but was rescued by public subscription. The fireplaces still retain the coat of arms of Archbishop Wareham (1504-1532).

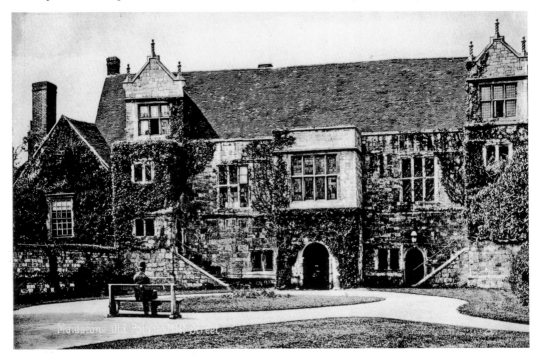

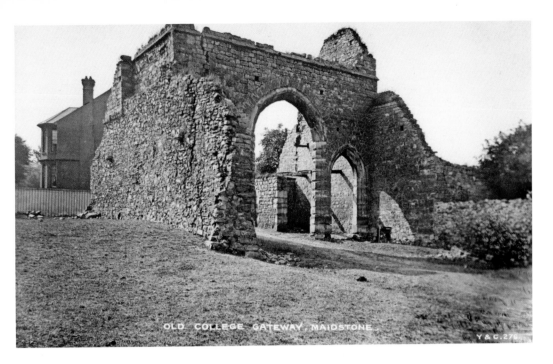

South Gatehouse of the Archbishop's College

In this photograph of the fourteenth-century gatehouse, taken in 1910, the carriage and footway arches are similar to those of the main fortified gatehouse nearer to All Saints'. Before College Road was built in 1863 the roadway used to pass through these two gatehouses. The only other college buildings anywhere near original condition are the Master's Tower and the Master's House, restored in 1956. When this area was excavated, foundations of massive medieval walls were found, suggesting that the Archbishop's precincts were fortified.

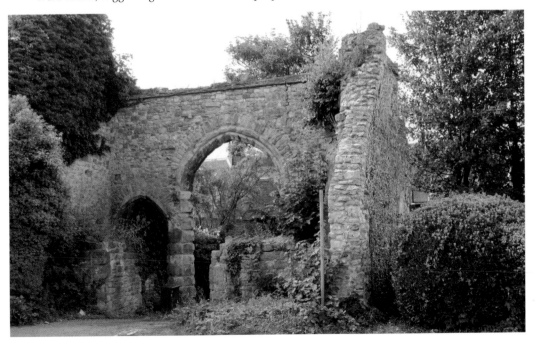

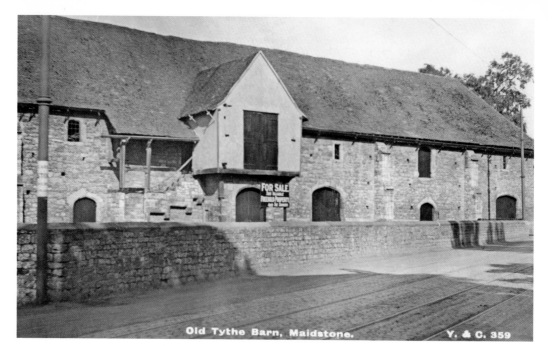

Old Tythe Barn, Maidstone. Y. & C. 359

The Archbishop's Stables or Tithe Barn

Also built in the fourteenth century, the Archbishop's stables probably provided accommodation on the top floor for the servants and grooms from the Palace. The horses would have been stabled on the ground floor. The building was used by Dorman's Tannery for many years and was purchased for the town in 1913. The premises now exhibit a unique collection of carriages first opened by Sir Garrard Tyrwhitt-Drake in 1946.

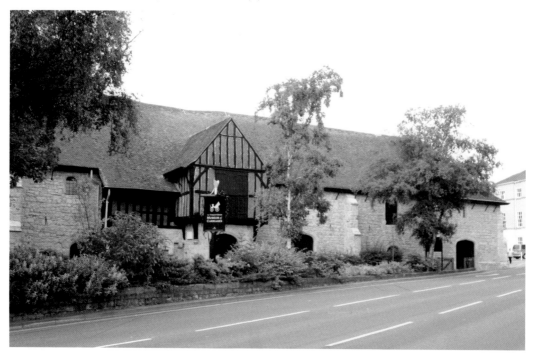

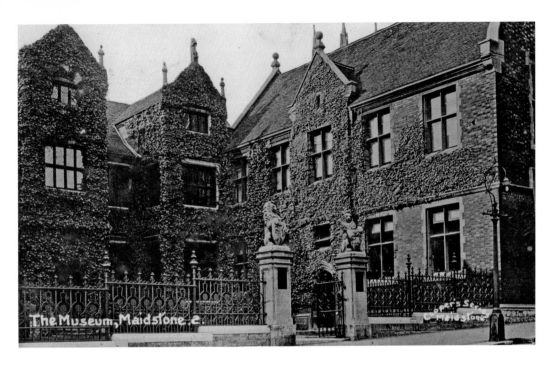

Chillington Manor House

Built in 1343, Chillington Manor was a sub-manor within the Archbishop of Canterbury's demesne. It was owned by various occupants until 1857 when it was purchased by Maidstone Corporation. The following year it was opened as a museum. Many additions and alterations have since been made to the original house.

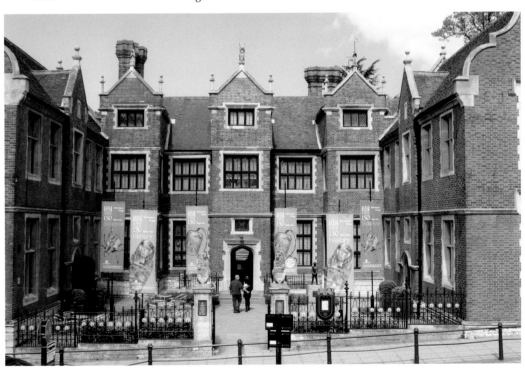

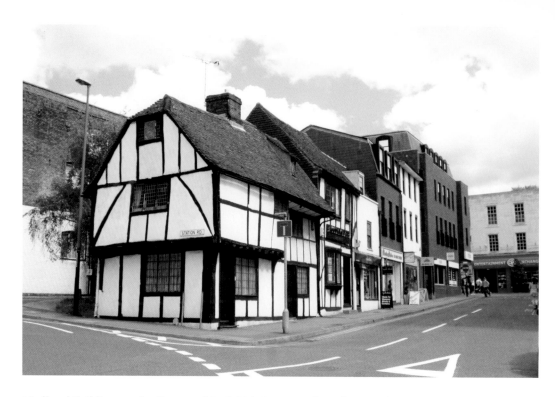

Medieval Building on the Corner of St Faith's Street and Station Road
The tiling of this building is now removed to reveal the original plaster and oak beams. In the early 1900s the premises were occupied by a newsagent and general grocer.

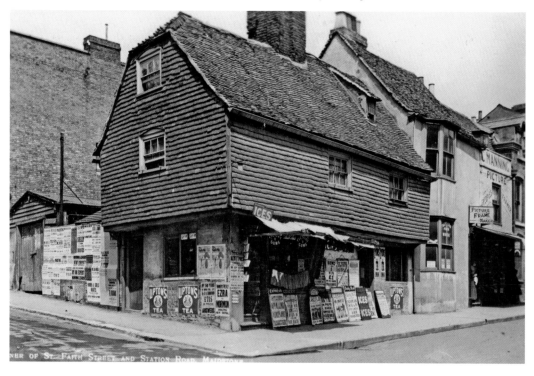

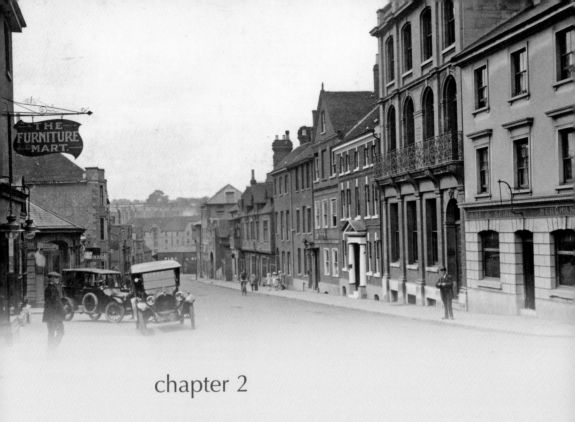

chapter 2

Streets

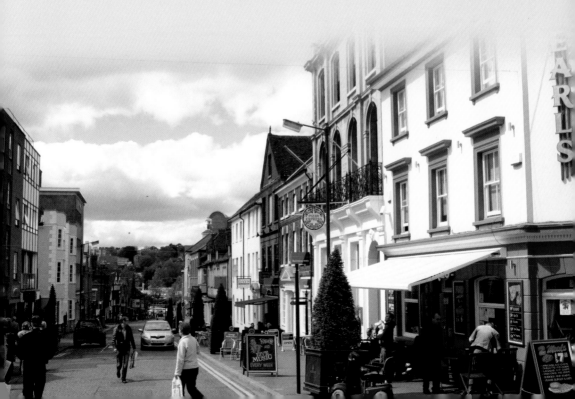

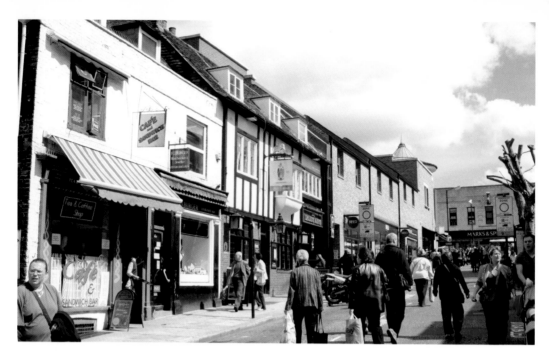

Earl Street

Modern shops line Earl Street today. Cruttenden's and the adjoining shop in Week Street have made way for Marks & Spencer's. The Roebuck Inn on the corner of Earl Street and Week Street was closed in 1920. This corner now forms the main entrance to the Fremlin Walk shopping centre. Earl Street, formally Bullock Lane, was the venue for the cattle market until 1826 when it was transferred to Fairmeadow. Note the large knife outside Cutler's shop at 12 Earl Street.

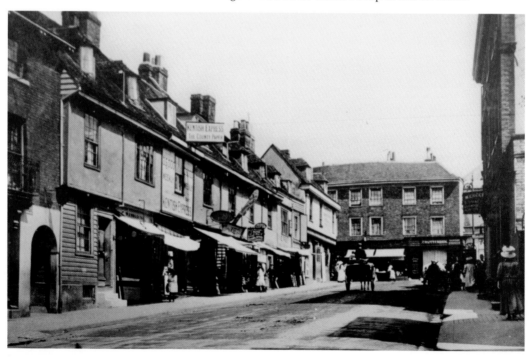

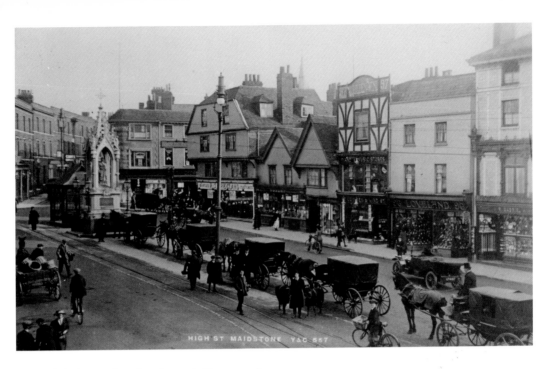

High Street showing Queen's Monument
Cabs waiting for fares in front of the Queen's Monument on the High Street in 1912. The cab rank provided horses for Maidstone Fire Brigade stationed in Market Buildings. Today the view is dominated by Colman House, an office block built in the 1960s.

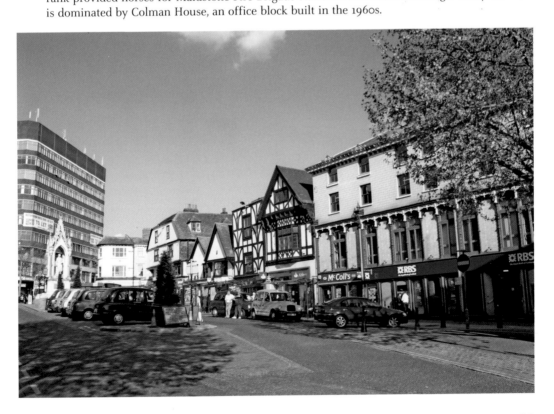

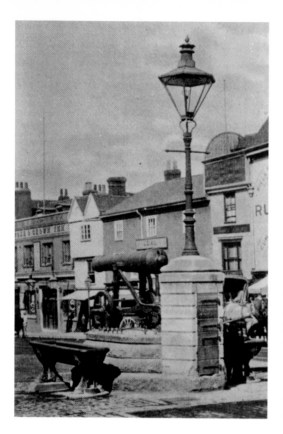

The Cannon

Another High Street view, photographed in 1900 when Maidstone was still lit by gas. It shows the Russian Gun, more popularly known as the Cannon, with two Victorian water troughs for horses alongside. The Rose & Crown Inn was a coaching inn with extensive stables at the rear. It closed in 1970.

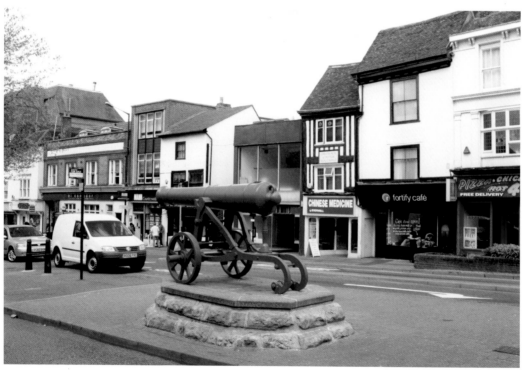

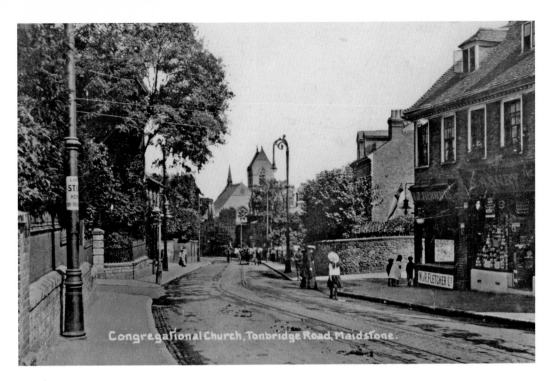

Tonbridge Road, 1910

In the distance of this photograph is Westborough Congregational church, built in 1876. It took the place of the old Bower Farmhouse at the junction of Bower Place and Tonbridge Road. Warwick House, behind the tree, was formerly Bower House. The church was demolished in 1977 and was replaced by a block of flats.

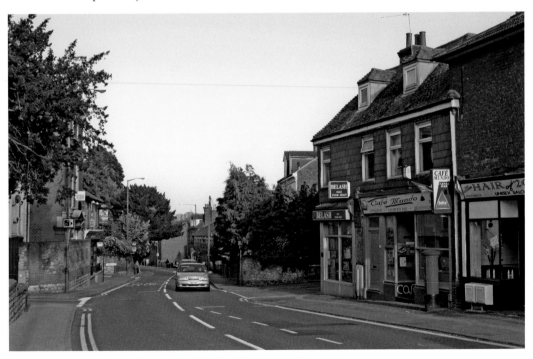

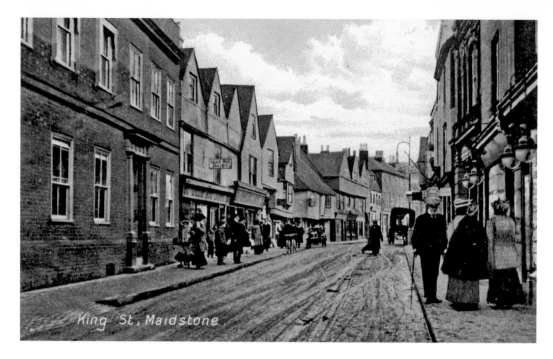

King Street Looking East, *c.* 1904

The house on the left had previously belonged to Thomas Cutbush, one of Maidstone's benefactors who died in 1871. When King Street was widened in 1927 the house was pulled down and the building that housed the general post office between 1928 and 2007 was built on the site. The Dog and Bear public house, which closed in 1913, stood on the far corner of Church Street. Somerfield's supermarket and car park can be seen there now. The police station was opposite Church Street until 1908; its lamp can just be seen on the other side of King Street.

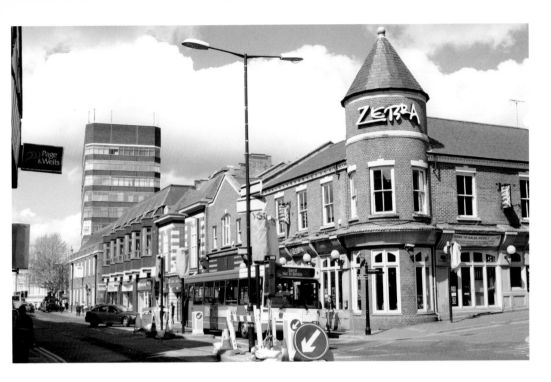

The Corner of King Street

The hundred-year-old photograph bears little resemblance to this corner of King Street today. After road widening in 1927, Clarke's furnishing store occupied this site but was destroyed by a disastrous fire in January 1995. It has since reopened on Sandling Road. The new building initially housed Yates's Wine Bar and later, the Zebra, which has now closed.

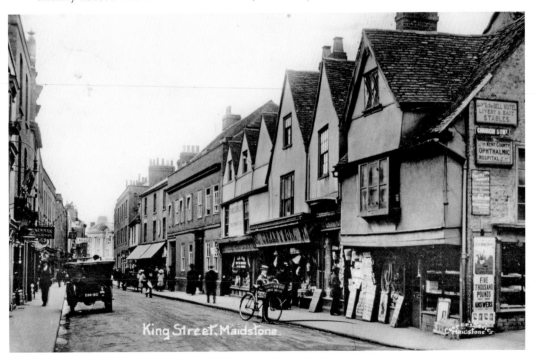

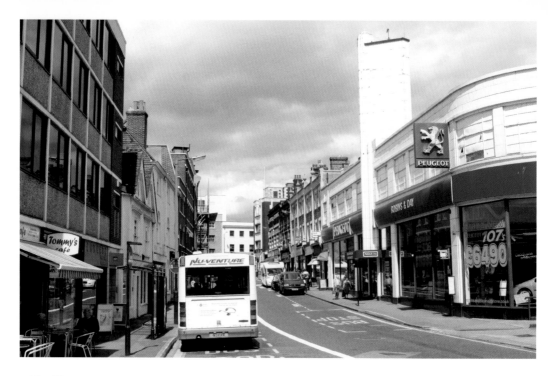

Old Mill Street

Church Mill, once located near the Len pond, was the origin of the name Mill Street. The millrace can still be seen at the Bishops Way junction. The photograph below of Old Mill Street was taken around 1905, before the street was widened to take the tramway to Loose in 1907. The entire east side of the street was cleared in the process.

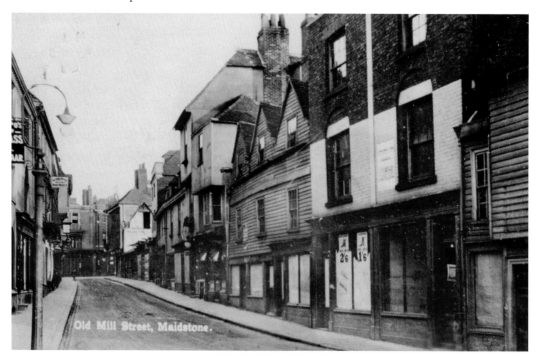

Old Mill Street, Maidstone.

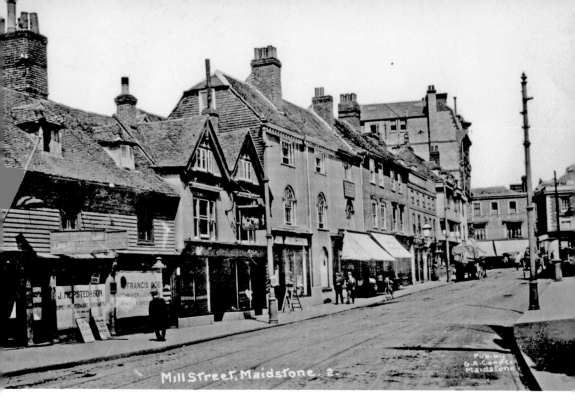

Mill Street, post 1907

The above photograph is of Mill Street after it was widened for the tramways. Unfortunately part of this side of the street was devastated by enemy action on 31 October 1940. It was later rebuilt.

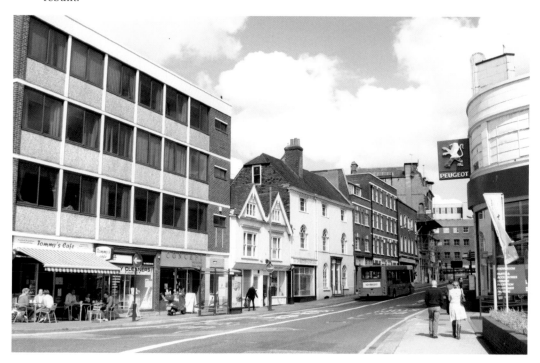

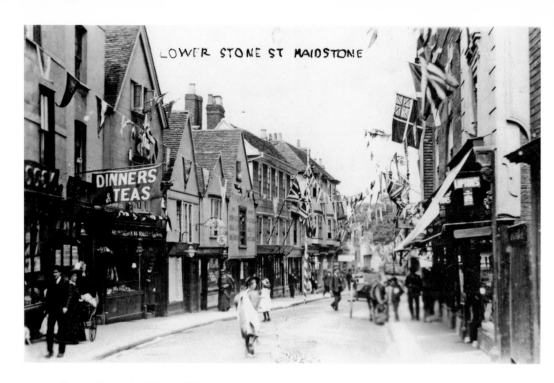

Lower Stone Street in Cricket Week, 1910
The Fisherman's Arms in the centre left (with writing on the front) is probably the oldest public house in the town, dating from 1430. It was tied to Mason's Brewery but was later taken over by Shepherd Neame of Faversham.

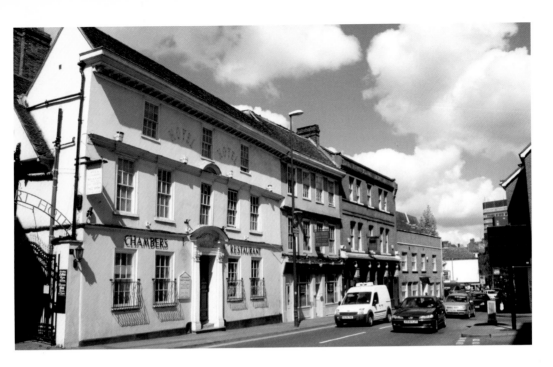

Stone House

Further down Lower Stone Street is Stone House, currently a luxurious hotel and restaurant. Originally it was a medieval house that was stone fronted in 1716. In 1915 Maidstone Co-operative Society and Midmore & Hall's Hardware Store were next door. The three gabled tenements were demolished to make way for Lower Stone Street Bus Station. Sadly the hardware store was severely damaged by fire in 1928 and Midmore & Hall reopened in the High Street. For many years Stone House was the official residence of the judges who attended the assizes.

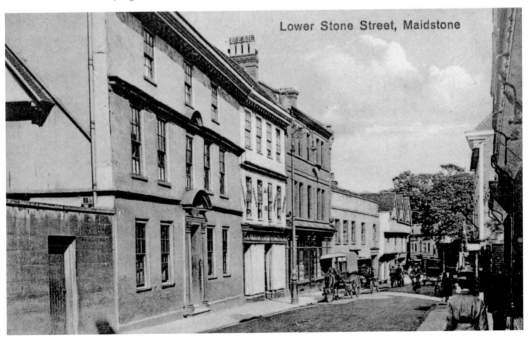

Lower Stone Street, Maidstone

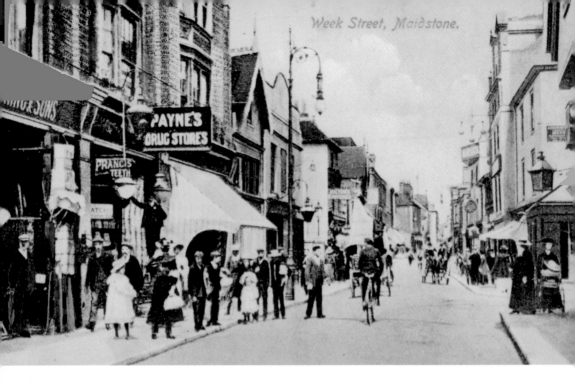

Week Street, 1909

At this time Week Street was Maidstone's main shopping centre. Since then three more shopping areas have been built: The Mall, Chequers, The Royal Star Arcade and Fremlin Walk. Week Street has, nevertheless, remained as popular as ever.

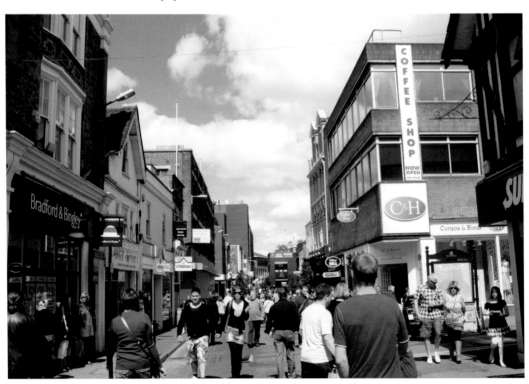

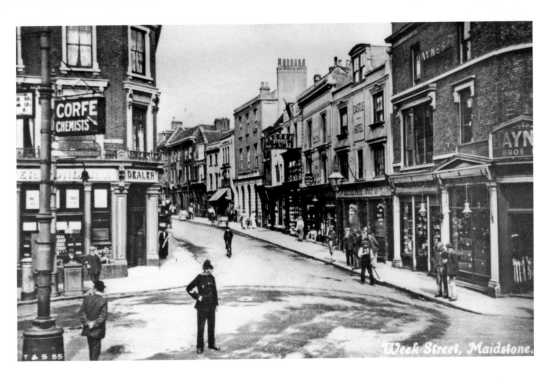

The Entrance to Week Street, Early 1900s

Haynes Bros occupied the King Street corner and the Red Lion public house was on the opposite corner. Week Street was named after Wyke Manor, which, according to the antiquary Revd Beale Poste, stood on the corner of Union Street. Week Street is now pedestrianised after being congested with traffic until 1970.

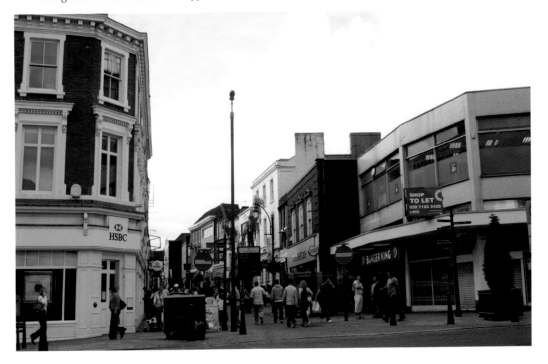

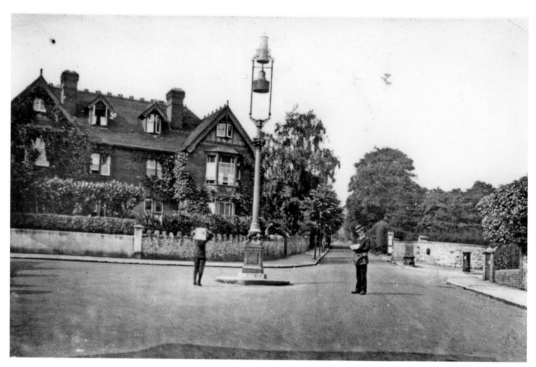

Sittingbourne Road

A postman was standing in the middle of an empty Sittingbourne Road at the beginning of the twentieth century. Vinters House and grounds were behind the wall on the right, with Union Street off to the left. A car park and Vinters Park housing estate now backs on to the Sittingbourne Road. The large house on the corner of Union Street remains.

Brenchley Gardens and St Faith's

The picturesque gateway to Brenchley Gardens was badly damaged by a German bomb on 27 September 1940 and the adjoining gardener's cottage was reduced to rubble. Another bomb that fell at the base of St Faith's tower made a crater thirty feet wide and split the clock tower from top to bottom. The pinnacles had been destroyed by lightning in the 1930s. Note the wrought iron construction which decorated the top of the Lower Brewery. It was salvaged when the brewery was demolished in 1970 and erected over the wishing well at the entrance to Brenchley Gardens.

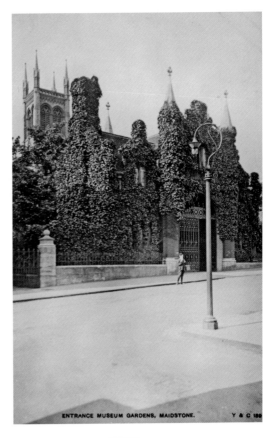

ENTRANCE MUSEUM GARDENS, MAIDSTONE. Y & C 199

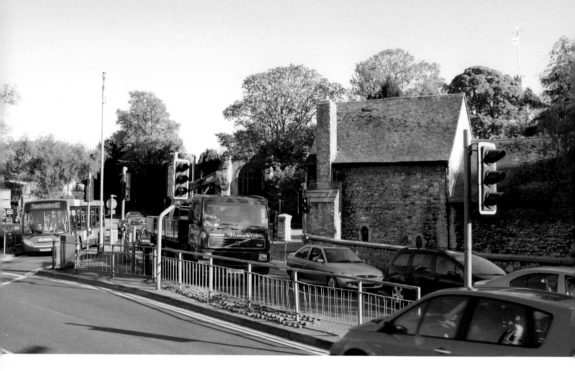

Bishop's Way

One of the busiest roads in Maidstone, Bishops Way was constructed in 1962 on part of Palace Gardens. The original Palace Gardens were purchased with the Archbishop's Palace in 1887. In 1904 the gardens were enlarged by with the addition of the grounds of Church Mill after its demolition in 1902. The view below shows part of the new, enlarged Palace Gardens shortly after it was opened.

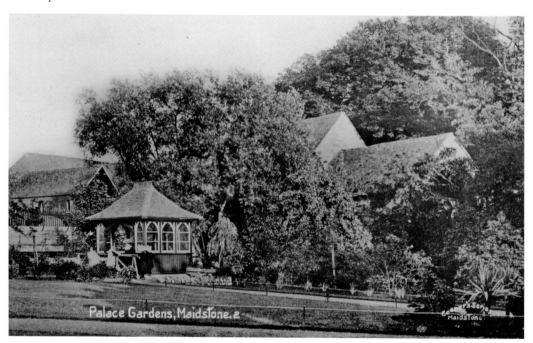

Palace Gardens, Maidstone. 2

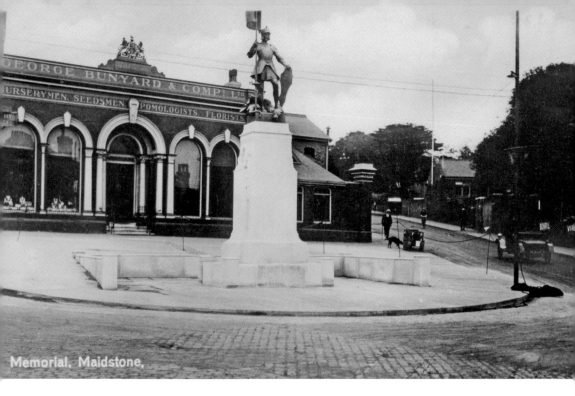

Maidstone War Memorial

Erected on the Broadway in 1922, the bronze figure of St George and the Dragon was designed by Sir George Frampton R.A. The arched shop belonged to George Bunyard, a local nurseryman who specialised in fruit. Today two conifers guard the memorial and the shop is waiting to be let.

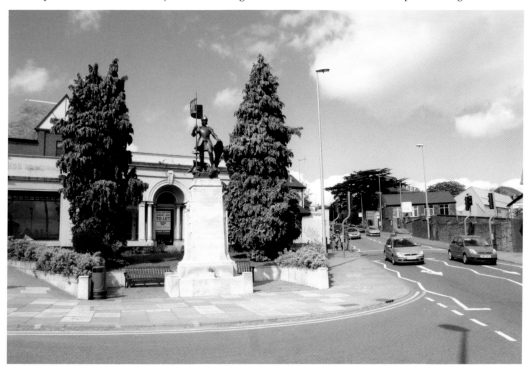

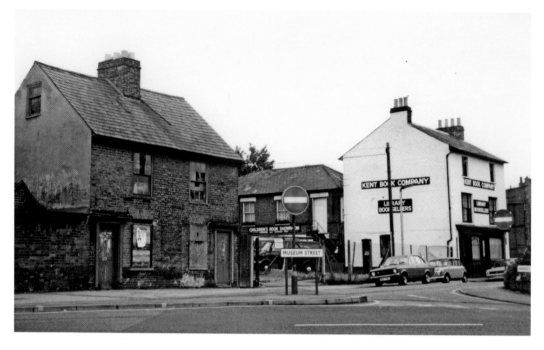

Fremlin Walk Shopping Complex
Museum Street, Market Street and all these buildings have made way for the Fremlin Walk shopping complex, constructed in 2005. The complex covers a vast area from St Faith's Street, Fairmeadow, Earl Street and Week Street and is now home to more than forty retailers.

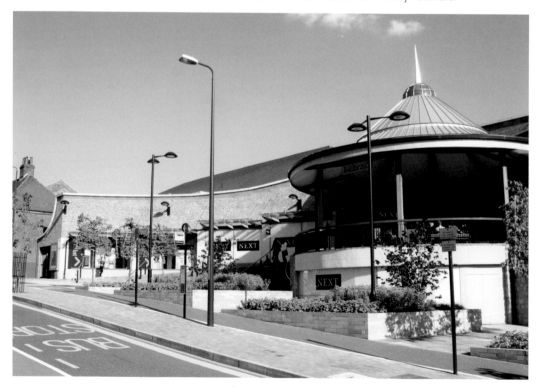

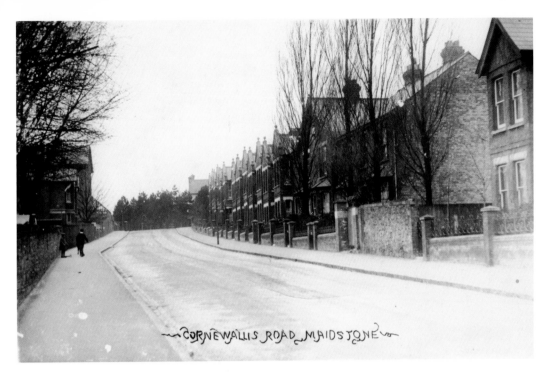

Cornwallis Road

Cornwallis Road

Like so many Victorian and Edwardian streets in Maidstone, Cornwallis Road has changed very little over the last century. Most of the trees have gone and car parking, although essential to residents, does little to enhance the appearance of the road.

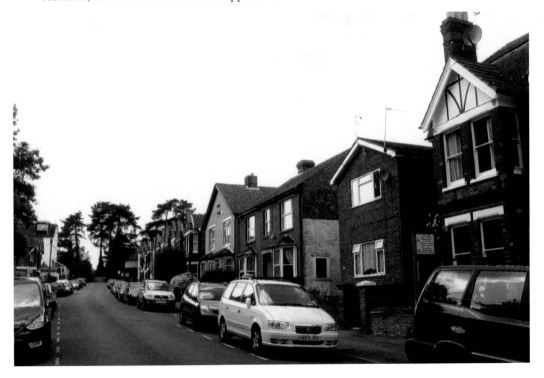

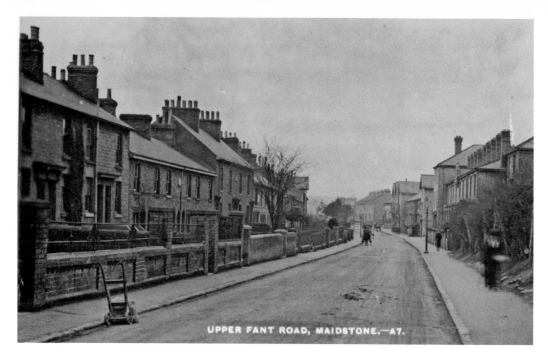

UPPER FANT ROAD, MAIDSTONE.—A7.

Upper Fant Road

Photographed here in about 1910, Upper Fant Road was part of the Fant housing estate, built on Fant Fields in the nineteenth century. The farm, farmhouse and oast have survived at the far end of the road. Pope Street, on the estate, is named after Horatio Pope who owned Fant Farm in the 1800s. Once again the road has hardly changed over the last hundred years apart from the street lighting, double-yellow lines and parked cars.

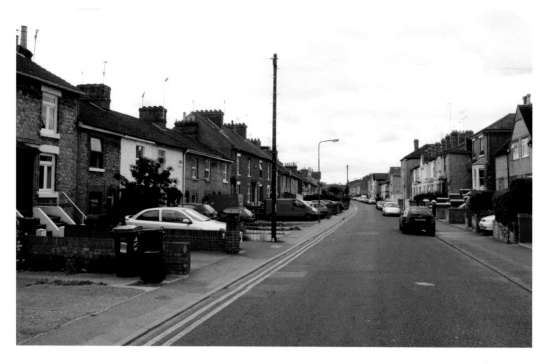

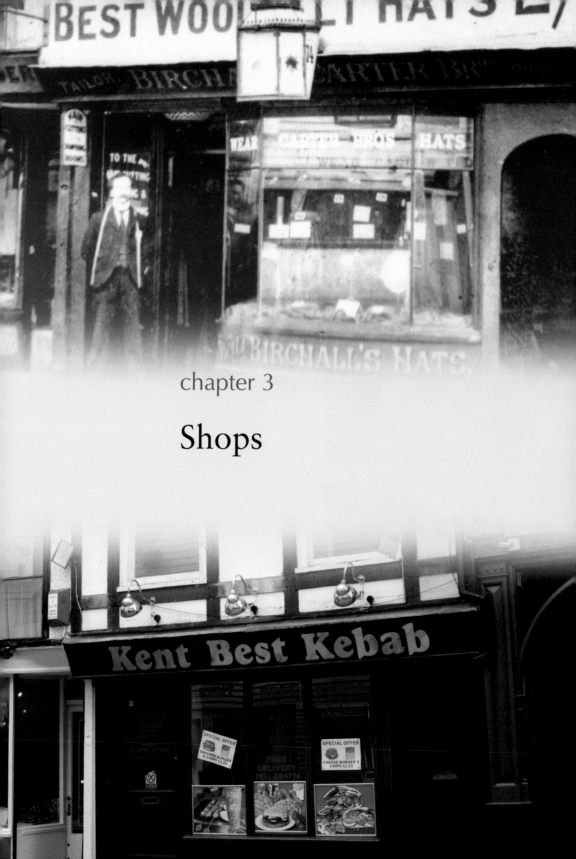

chapter 3

Shops

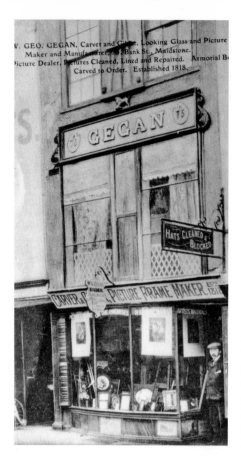

Gegan's Picture Framers, 1900

William George Gegan's picture framing business at 75 Bank Street was established in 1818. Gegan's did most of the picture framing, cleaning and restoring for the larger households in Maidstone. He was also a carver and gilder. Gegan's was next door to Birchall's, as shown on the previous page. Now they are a kebab shop and hairdresser's.

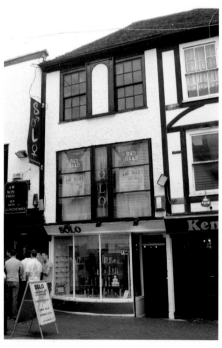

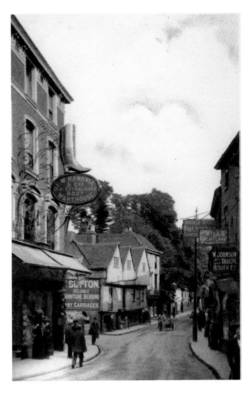

Randall's Boot Warehouse, 1917
Located on Gabriel's Hill, Randall's Boot Warehouse opened in 1790 and is still trading today. It is now called 'The Golden Boot' named after the six foot high Golden Wellington Boot that has embellished the front of the building for more than 150 years. Water Lane, off to the left, has disappeared under The Mall Chequers. Button's shop was demolished in 1936 and replaced by Art Deco shops and offices.

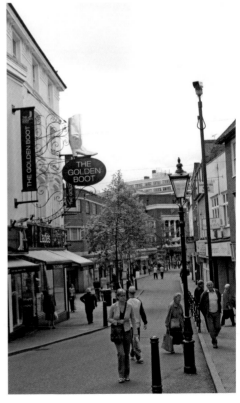

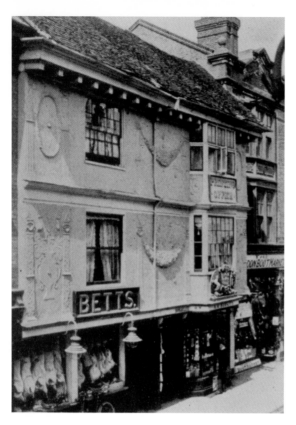

Betts' and Burkitt's
Fine pargetting, dating from 1680, decorates the front of these shops in Week Street and still survives today. In 1910 Betts' the butchers traded in one shop and Burkitt's printing and stationary business in the other. Until moving to Fremlin Walk, Boots occupied the building, but it is now a charity shop selling second-hand furniture. The London Boot Market was next door.

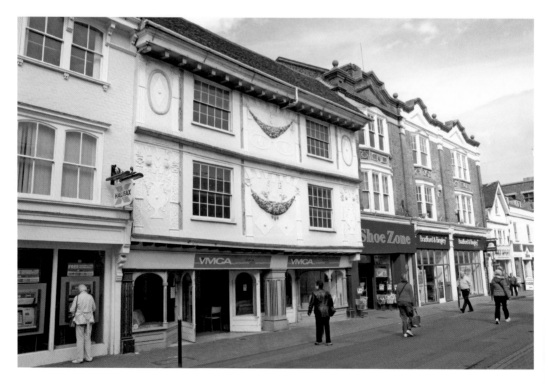

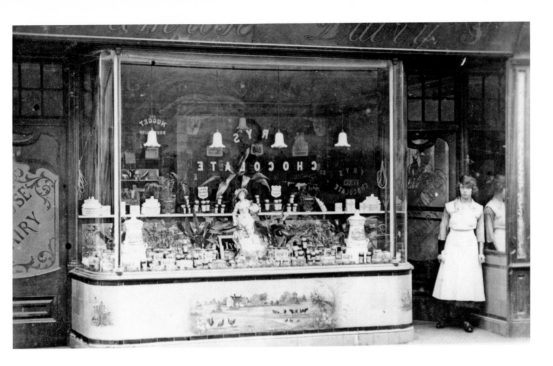

Jordon and Pawley's Primrose Dairy, 1910

The reflection of the words 'Fry's Chocolate' in the window is from a stationary vehicle in the road. Walter Wickens, who was the proprietor of the Len Dairy in Romney Place, purchased the Primrose Dairy on 32 King Street in the 1920s. In the early 1970s Primrose and Len Dairies were taken over by the Express Dairy. No. 32 is now a florist shop.

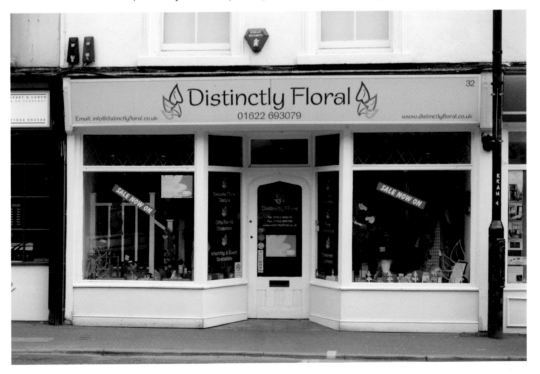

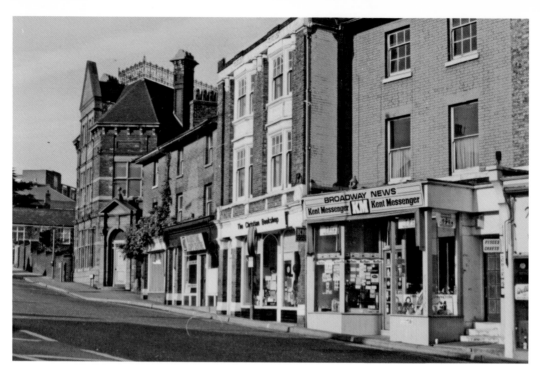

The Broadway, 1980

The tall brick building was the work of George Whitcombe, a monumental sculptor from King Street. It housed the offices of Style & Winch (later Courage's) and was the last remaining part of the Medway Brewery. All these buildings have since been demolished to make way for the Broadway Shopping Centre.

Hardy Street General Store

The general store and post office on Hardy Street closed in 2007. The lower picture shows soldiers lining up for the photograph outside the shop in 1914. Note the Victorian post box at the front of the shop. Today a more modern example on the side of the building is the only sign that it was once a post office. In 1870 the building was a beer house known as The Cannon.

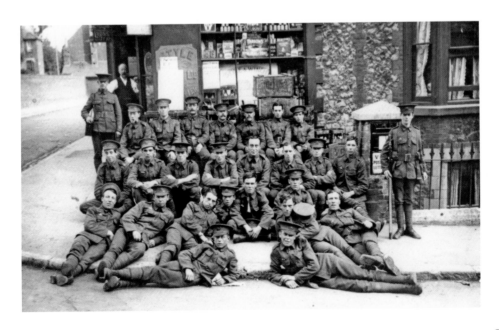

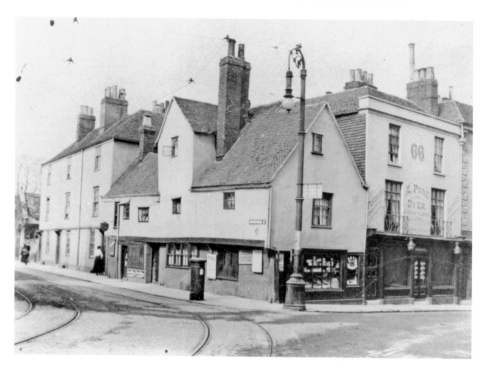

Lindridge's General Shop, 1908

Located on the corner of Knightrider Street and Stone Street, the building dates from the sixteenth century and was formerly known as Mill Farm House. The tram tracks had just been laid for the tramway to Loose. The building now displays its half timbering and is a public house called the Thirsty Pig.

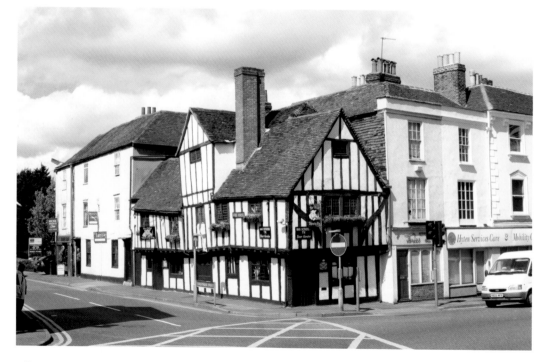

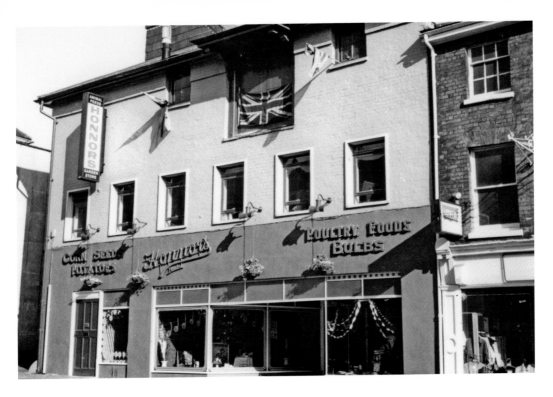

Honnors Corn & Seed Merchants, 1977
Honnors once had a store on Week Street and a warehouse in Waterside. The 17 Earl Street premises, photographed above, closed in 1988 and are now occupied by Waterstone's bookshop.

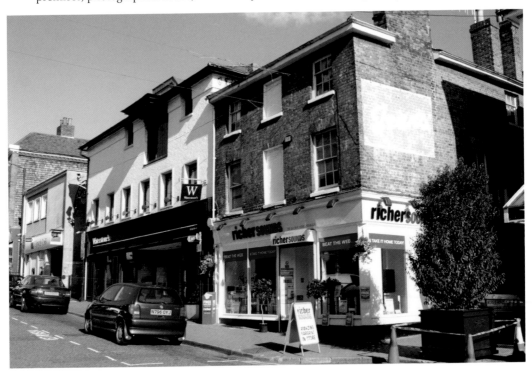

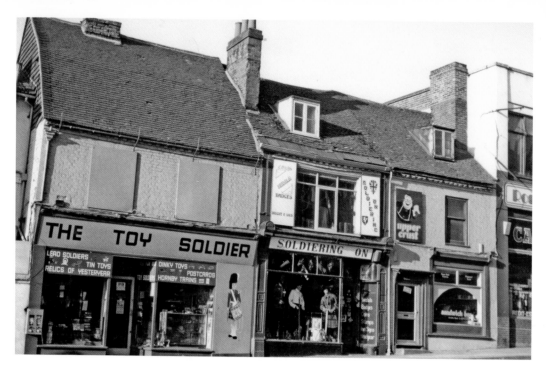

The Toy Soldier and Soldiering On

These shops on the Broadway, managed by Bill Kingsman and his brother, were very popular collecting centres in the 1970s. Unfortunately they, and other shops as far as the Elephant & Castle on the corner of Hart Street, were demolished in the late 1980s. A car showroom has since been built on the site.

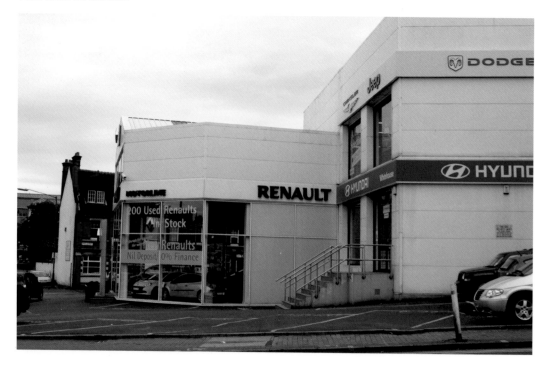

chapter 4

Transport

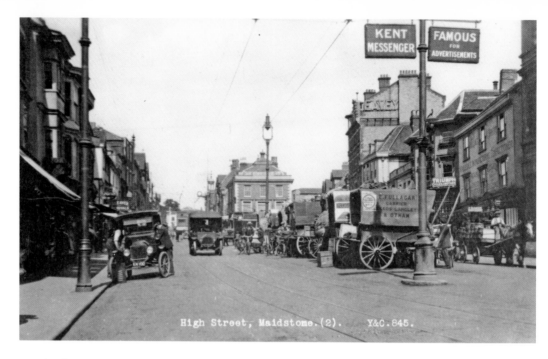

High Street, Maidstone. (2). Y&C.845.

Carriers' Carts

Lined up in front of the gas showroom in the lower High Street in about 1916, carriers' carts provided a regular daily service to Maidstone from the outlying villages. The horses were fed and watered at local stables, usually at the Queen's Head or the Rose & Crown. The carts gradually disappeared as motor transport took over. Since then the gas showroom was rebuilt for Barclays Bank in 1963 (now to let), the shops were re-fronted and trees planted where the carts used to stand.

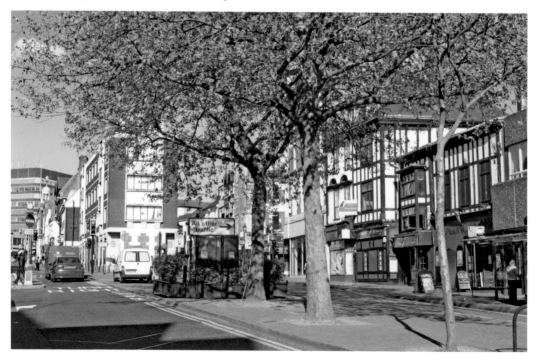

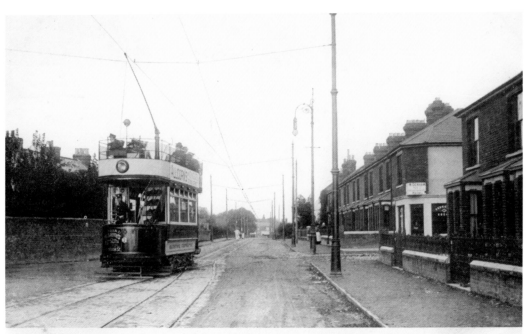

TONBRIDGE ROAD, MAIDSTONE. TERMINUS OF TRAMWAY.

Barming Fountain Inn Tramway Terminus

In 1904 six trams inaugurated the service from Maidstone to Barming. The photograph shows tram no. 6 leaving the outer terminus at Barming Fountain Inn. By this date housing had extended this far up the Tonbridge Road, and the side road on the right became Terminus Road.

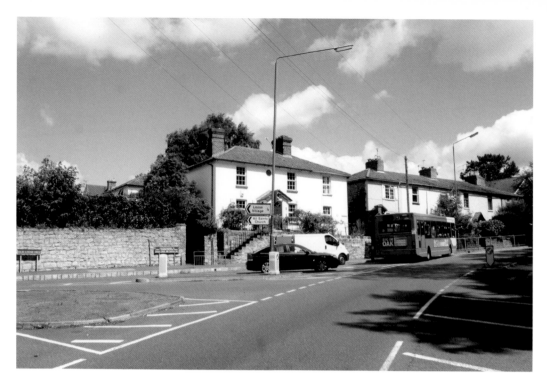

Loose Tramway Terminus

Below shows Tram no. 14 at the Loose terminus at the King's Arms in 1908. A second tram service to Loose was opened in 1907 and a third to Tovil in 1908. Ten extra trams were purchased for the new routes. The route to Loose was converted to trolleybus operation in 1930.

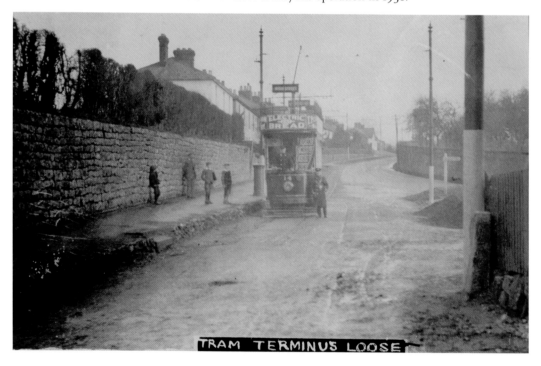

TRAM TERMINUS LOOSE

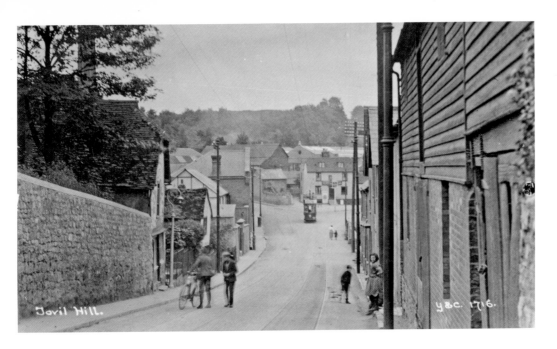

Tovil Tramway and Papermills

The Tovil Tram standing at the terminus at the Rose Inn. The Tovil tramway was not as successful as the Barming and Loose services, so a one-man operated single decker was introduced in 1909 in place of the conventional trams. After the First World War the original trams were reinstated owing to an upsurge in labour at the Tovil paper mills. Tovil trams were replaced by motor-buses in 1929. Today all the paper mills have been replaced by housing and the Rose Inn has recently been demolished. Only the pub at the top of the hill records the area's history.

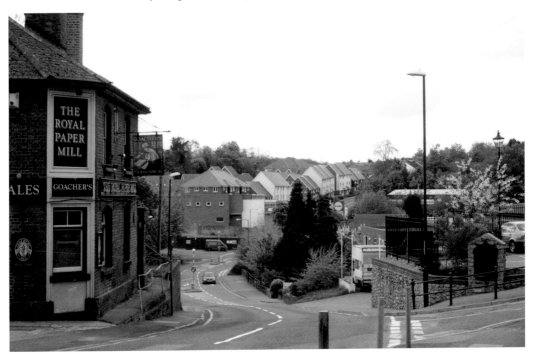

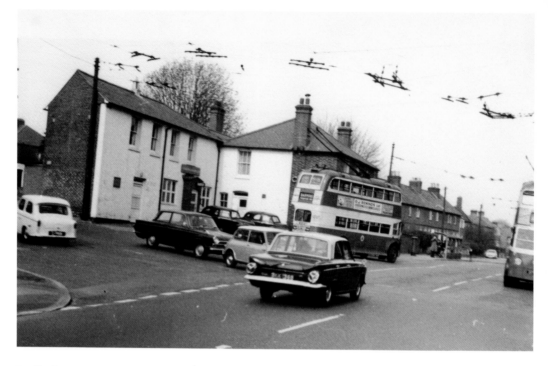

Trolleybuses at Barming Fountain Inn

The Barming trams were replaced by trolleybuses in 1928. This photograph shows two trolleybuses at the terminus at the Fountain Inn, Barming, in the 1960s. Trolleybuses continued in operation in Maidstone until 1967 when they were replaced by motor-buses. Buses abandoned the U-turn manoeuvre here in 1976 because of increasing traffic.

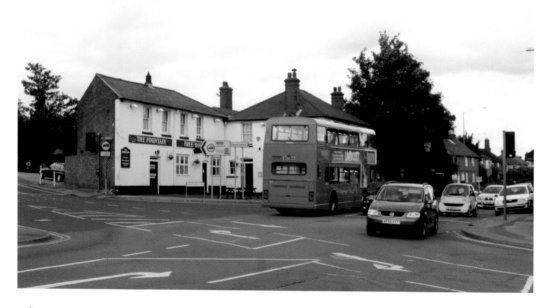

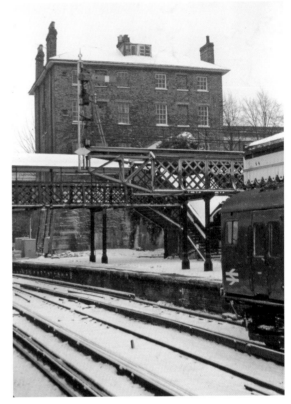

Maidstone West Station

In January 1979, a 1950s train waits to depart from a snowy Maidstone West Station for Strood. By June 2009, the train had become a 1990s Networker and the semaphore signal had been replaced by a colour light signal.

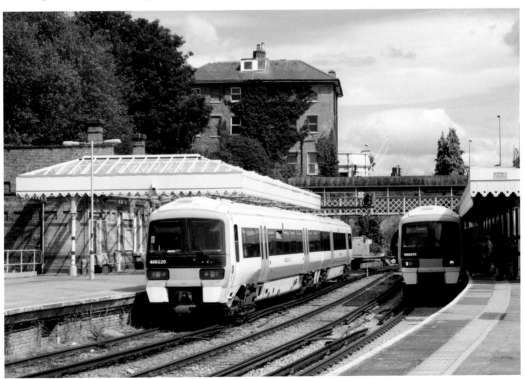

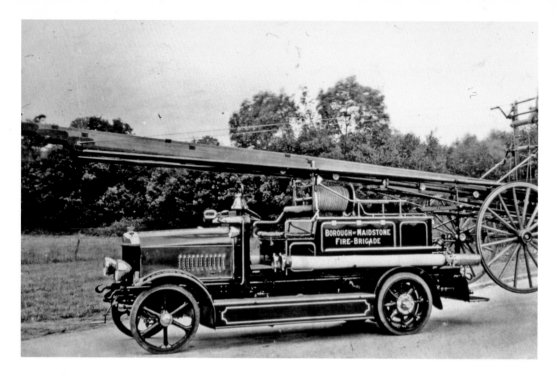

Ethel the Fire Engine

In December 1914 the Corporation purchased Maidstone's first motor fire engine (KT3812), named *Ethel*. She was built by Dennis Bros and cost £1,059. The fire station in Market Buildings, nicknamed 'The Cupboard', had to be enlarged to accommodate the new engine. Ethel was in service up to the Second World War. A new fire station was built in Loose Road in 1958 and the fire engines have become more sophisticated.

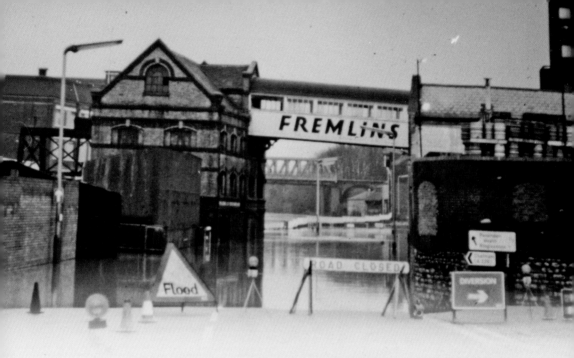

chapter 5

A Working Life

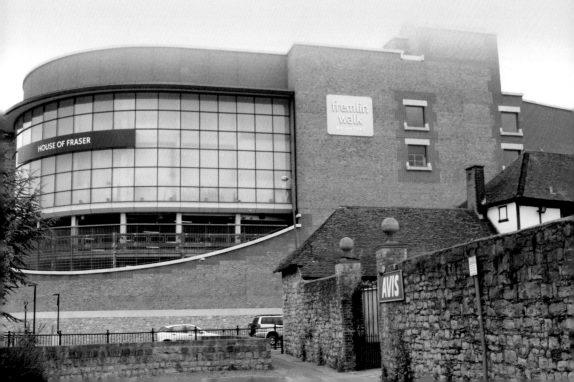

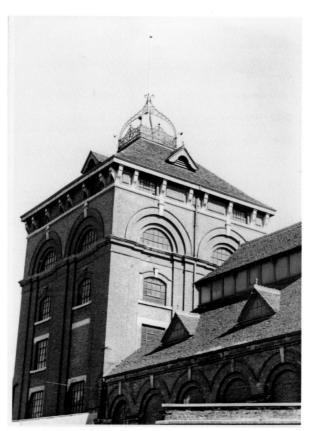

Fremlin's Brewery

Fremlin's acquired Isherwood, Foster & Stacey and their Lower Brewery in 1929. Brewing ceased and the building was then used by Marchant & Tubbs, a clothiers, and boot and shoe warehouse. This photograph was taken shortly before demolition in 1970. The ironwork construction at the top was saved and can be seen on page 25. The photograph below shows the site of the former brewery, now part of The Mall Chequers, behind Hubble & Freeman's shop and the Gala Bingo hall.

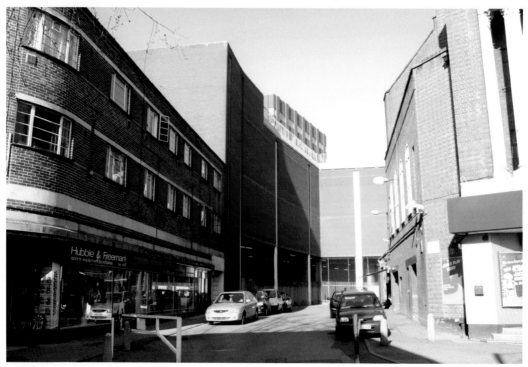

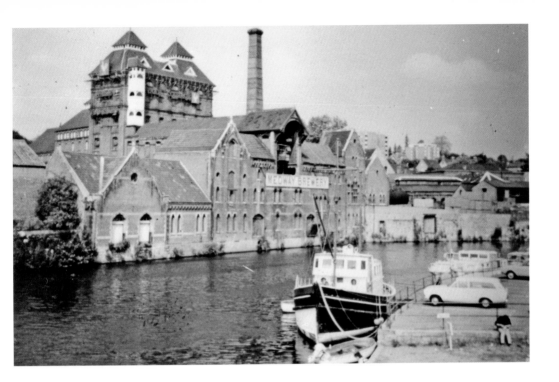

The Medway Brewery, 1975

Originally built in 1806, the Medway Brewery on St Peter's Street was modernised and extended in 1899. At that time the owners were A. F. Style and E. Winch. In 1929 the brewery became part of the Courage, Barclay and Simmonds Group. It closed in 1975, soon after this photograph was taken. St Peter's Street is hardly recognisable today since major changes occurred when St Peter's Bridge was constructed in 1978, followed by the Broadway Shopping Centre in the 1980s.

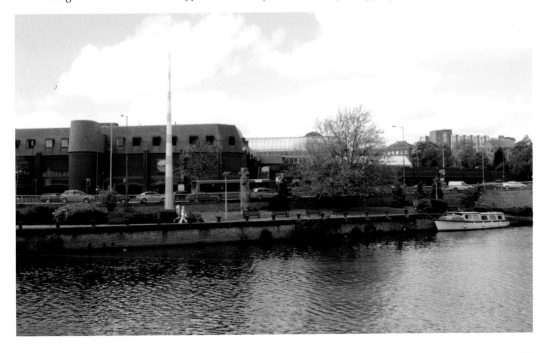

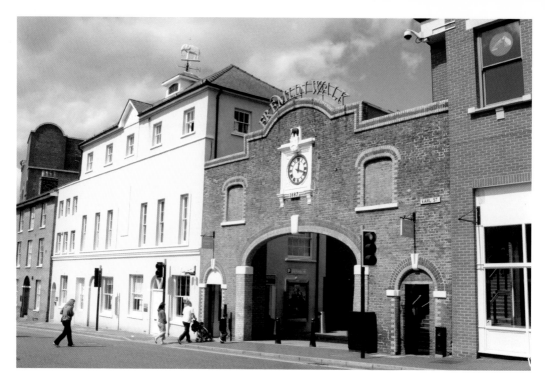

Fremlin Walk Shopping Centre

Fremlin's Brewery was demolished in 1980, giving way to Fremlin Walk shopping centre. All that survives of the brewery is their main archway and the golden elephant (Fremlin's trademark) on the weather vane. The photograph below, taken in the 1970s, shows Fremlin's Brewery with Corpus Christi Fraternity Hall in front. The hall, formerly Maidstone Grammar School, was taken over by Fremlin's for a cooperage in 1871.

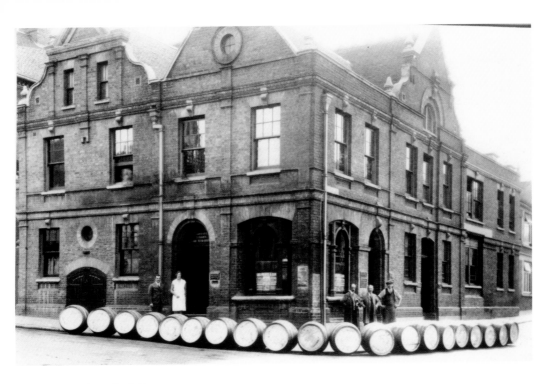

George Prentis & Sons, 1930
A wine and spirit merchants at 37 Earl Street (on the corner of Pudding Lane). The building still retains early vaults dating from 1764. Fremlin's took over the premises in 1960. Recently Invicta Radio used the building and now it is the Wildwood Restaurant.

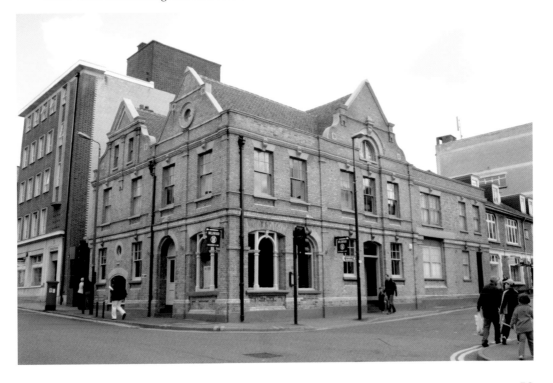

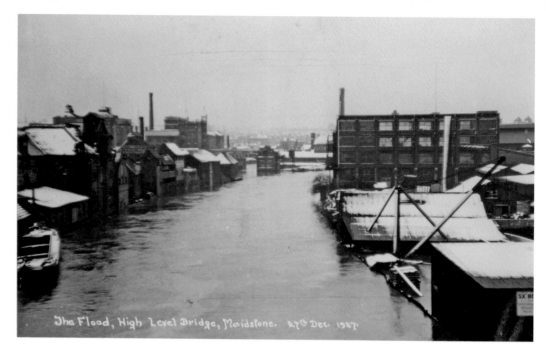

The Flood, High Level Bridge, Maidstone. 27th Dec. 1927.

The River Medway

A view of the Medway taken from the High Level Bridge during the 1927 floods. Mason's Brewery can be seen about halfway along on the left bank with Fremlin's chimney just behind. On the right is Drayson's timber yard at Baltic Wharf, later Tilling-Stevens Works, and the large building is Sharp's sweet factory. All these buildings have since been cleared for another housing development as seen on the next page. High-rise flats and the extensive Fremlin Walk shopping centre now dominate the left bank.

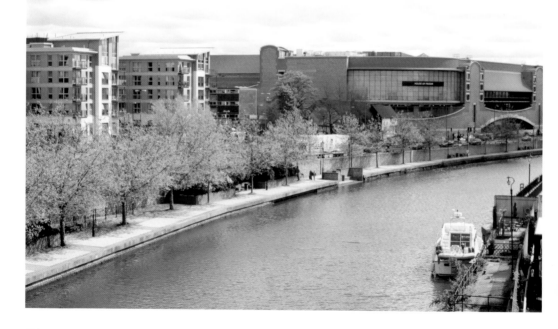

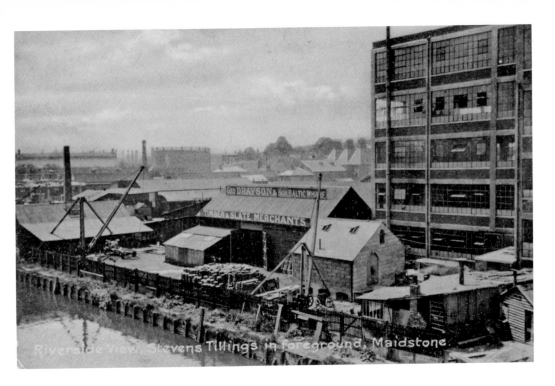

Tilling-Stevens Works

This is Tilling–Stevens' 'new' factory works at Baltic Wharf, built in 1920. Tilling–Stevens prospered and their passenger vehicles and lorries were shipped all over the world. In 1952 they were taken over by Rootes and finally closed in 1977.

Much of the riverside has been cleared for a new housing development but the multi-storey factory remains and is let out to small firms.

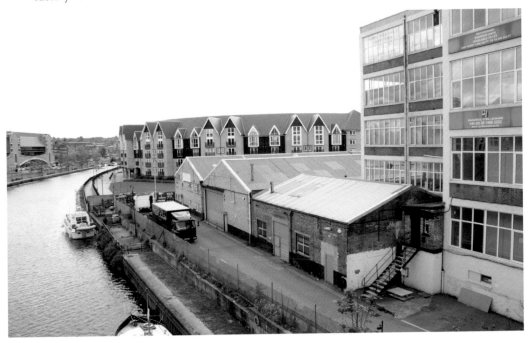

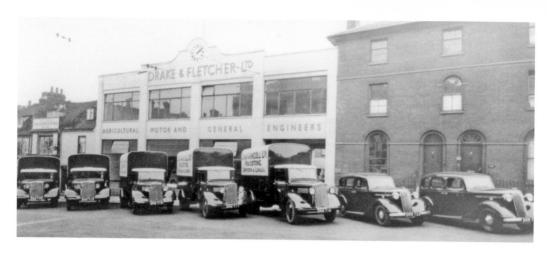

Drake & Fletcher Ltd

In 1900 Drake & Fletcher entered the agricultural and motor trade business. This photograph shows a line up of Bedfords and Vauxhalls in front of their newly built premises in the Broadway in 1936. Mr and Mrs Drake and Mr and Mrs Fletcher shared the house on the right, later to be used as their head office. In 1972 the firm of Drake & Fletcher Ltd moved to Sutton Road, Park Wood.

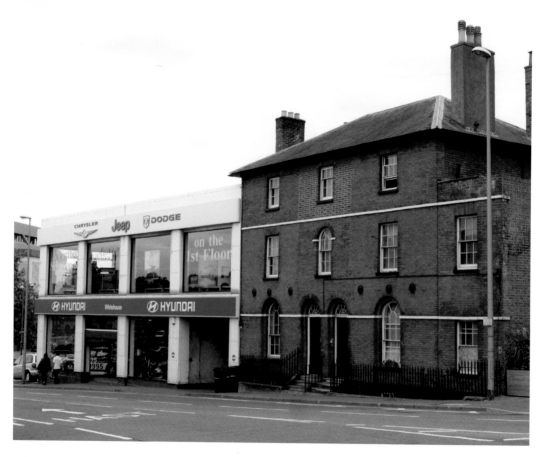

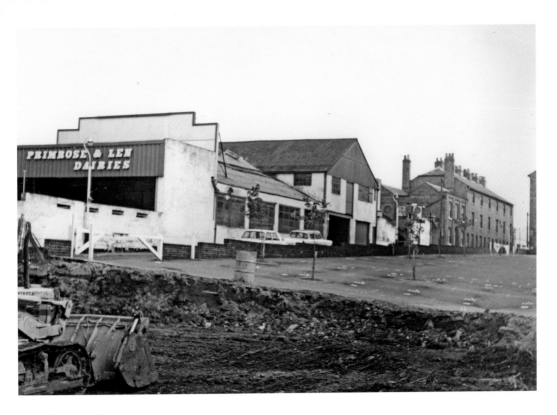

Romney Place
Primrose & Len's Dairies and houses in Romney Place photographed just before they were cleared to make way for Stoneborough shopping centre (now The Mall Chequers) in 1975. Romney Place is now a busy thoroughfare with queues to the Mall, the bus station and Sainsbury's.

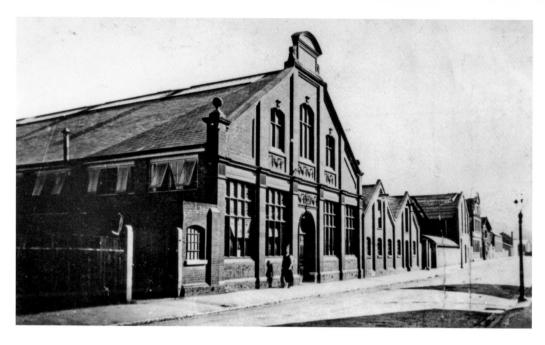

Eiffel Tower Works, Hart Street

Another well-known manufacturer in Maidstone was George Foster Clark who registered under the trade name 'Eiffel Tower'. He purchased a factory in Hart Street in 1895 where he manufactured lemonade, blancmange powder, jelly, bun flour and baking powder. The Foster Clark name was sold to Oxo Ltd in July 1965 and the 'Eiffel Tower' works closed. Hart Street today is completely unrecognisable.

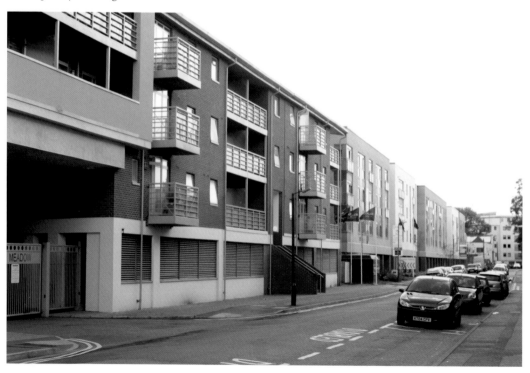

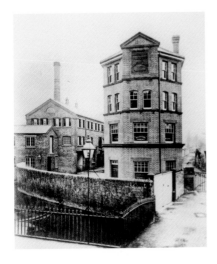
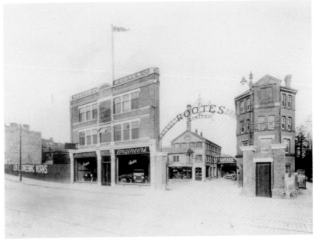

The Maidstone Tannery

Built on Mill Street in 1900, the Maidstone Tannery was taken over by William Rootes Snr, a motor manufacturer in 1917, and was known as the Len Engineering Works. By 1922 an ornamental archway, car and accessory showrooms had been added. In 1931 Rootes launched the Hillman Minx, which became the most popular car in the world. The present Art Deco showrooms were built on the same location in 1937/8. The business is now under the name of Robins and Day who are a Peugeot dealer.

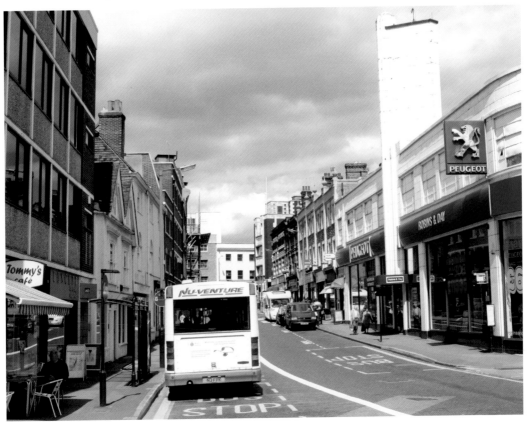

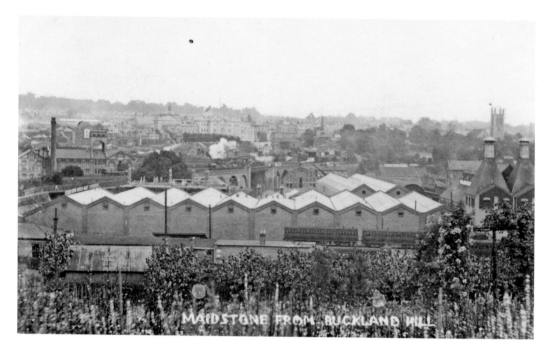

Maidstone from Buckland Hill, 1916

In the foreground are the Victoria Works where W. A. Stevens started his electrical business in 1897. He designed the electricity supply system for Maidstone's lighting in 1901. In 1913, when Thomas Tilling decided to use Stevens' petrol-electric system for his buses, the firm Tilling-Stevens Limited was formed. Jewson building suppliers now occupy the former Victoria Works.

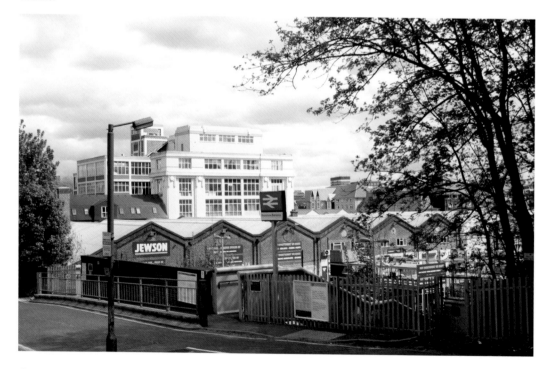

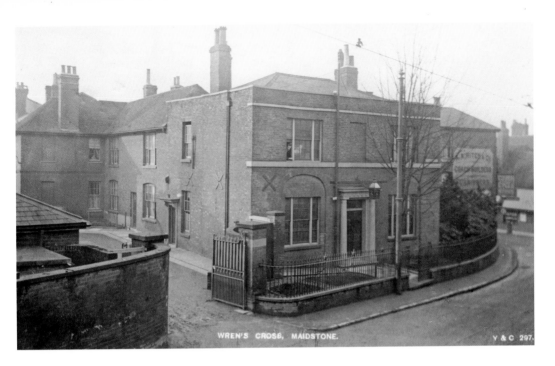

WREN'S CROSS, MAIDSTONE.　　　　　　Y & C 297.

Wren's Cross

Situated at the junction of Stone Street, Knightrider Street and Mote Road, Wren's Cross was taken over as headquarters for the Kent County Constabulary in 1857. Wren's Cross remained the headquarters until 1940 when new premises were established in Sutton Road. Currently Wren's Cross awaits redevelopment.

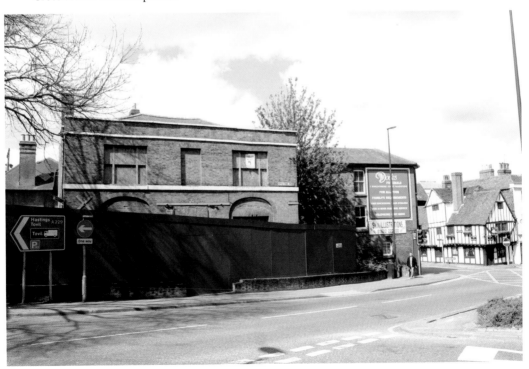

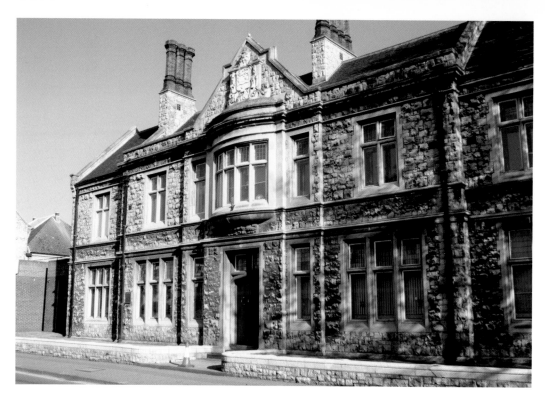

Maidstone Police Station

Built in 1908, the Maidstone Police Station on Palace Avenue is still in use today, although much enlarged and modernised. The photograph below shows Maidstone Police Force outside the station in 1914. The building superseded the former police station in King Street.

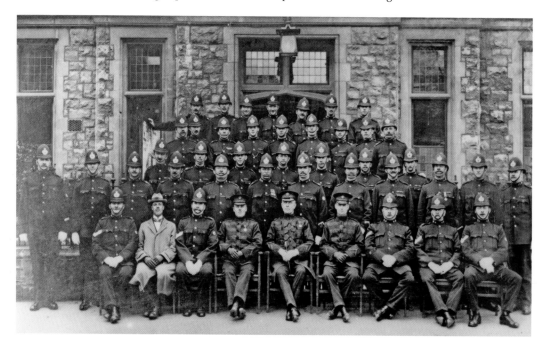

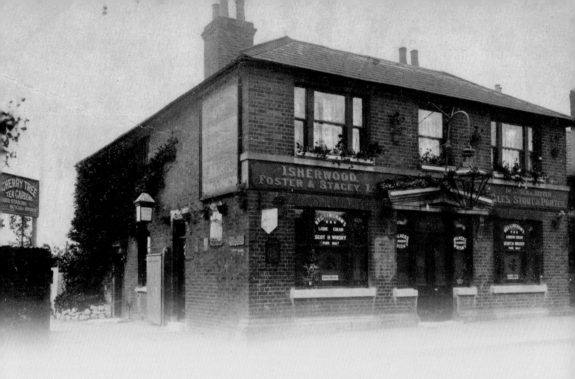

chapter 6

Inns And Taverns

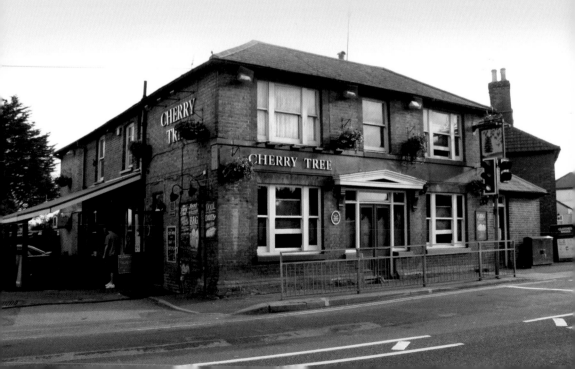

The Corner of St Faith's Street and Waterside

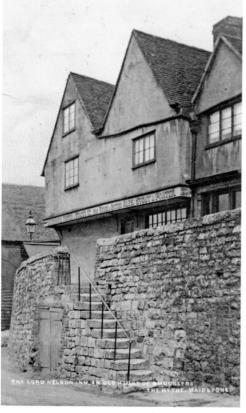

This Chinese restaurant on the corner of St Faith's Street and Waterside was previously the Lord Nelson Inn. It was built in the fourteenth century and was generally believed to be a haunt for smugglers. When the inn closed in 1938, the licence was transferred to the Sir Thomas Wyatt public house at Allington.

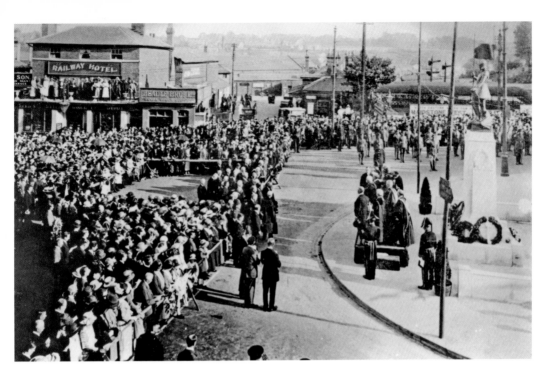

The Railway Hotel

The roof of the Railway Hotel was very popular when the war memorial was unveiled on the Broadway in 1922. The hotel opened when the railway reached Maidstone West in the nineteenth century and, being in close proximity to the railway and Maidstone Market, trade flourished. Like many other drinking establishments, trade dwindled in later years and there are now high-rise flats on the site.

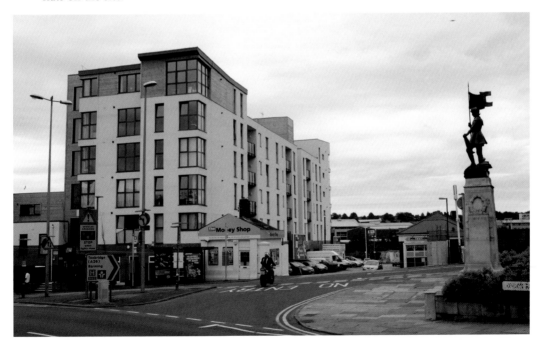

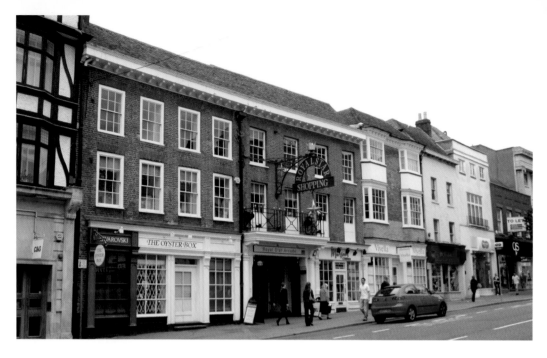

The Royal Star Hotel

The present Royal Star Shopping Arcade on the High Street was converted from Maidstone's leading hostelry, the Royal Star Hotel, in 1986. The Royal Star, noted for its Saturday night dances, was originally a coaching inn. Further along was the Haunch of Venison Hotel that closed in 1917, and Market Buildings, leading through to Earl Street. It was from the balcony of the Royal Star that Disraeli thanked the electorate for electing him M.P. for Maidstone in 1837.

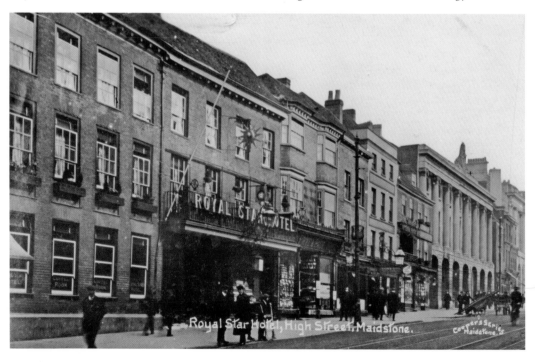

Royal Star Hotel, High Street, Maidstone.

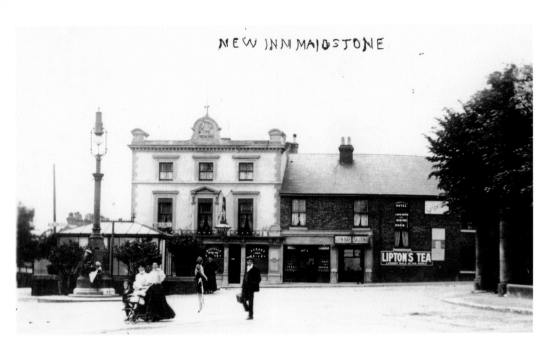

The New Inn and Public Toilets, 1908

The inn, located at the top of Week Street, dates back to 1860. When Maidstone East railway station opened in 1874, the establishment became known as the New Inn & Railway Hotel. After the Second World War the hotel was renamed the Wig & Gown. The premises were demolished in the 1980s to make way for the Invicta House office block. On the right is County Hall, built in front of the Sessions House in 1915. This area is a popular venue for a farmers' market.

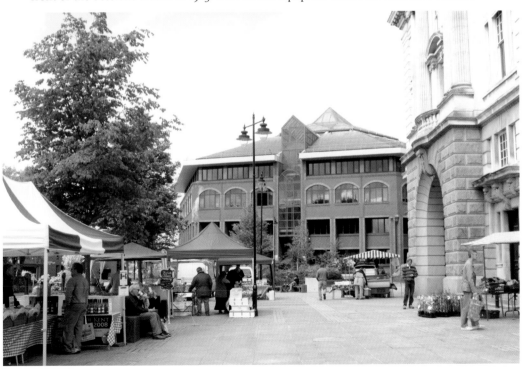

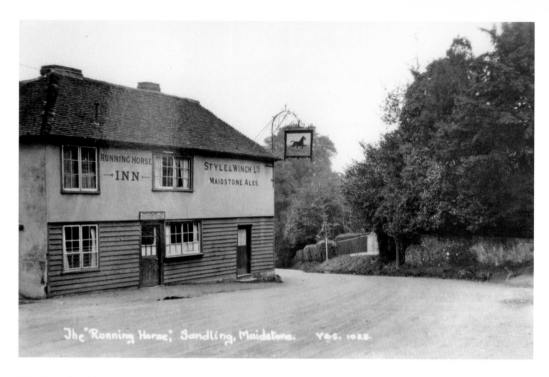

The Running Horse, 1910

A new Running Horse in Mock Tudor style with Norfolk reed thatch was built on the site of the country pub on Old Chatham Road in 1938. It was modernised again in 1987 and is now a Harvester restaurant and public house.

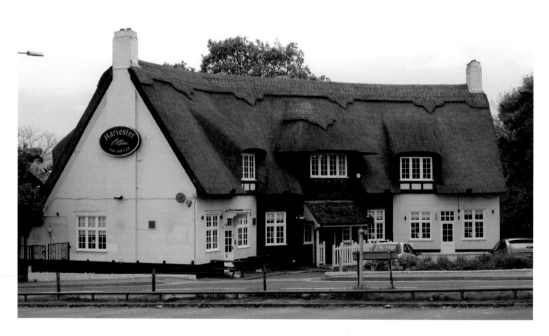

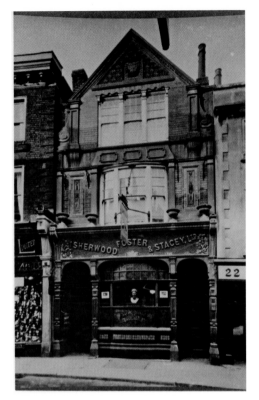

The Fountain Inn

An Isherwood, Foster and Stacey public house in Week Street, the Fountain Inn was noted for its colourful façade of blue-green embossed tiles and the smiling figurehead of a woman looking out on Week Street. The Fountain Inn closed in 1969 and is currently a travel agent's.

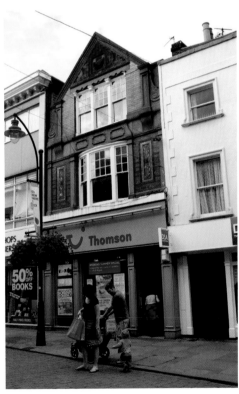

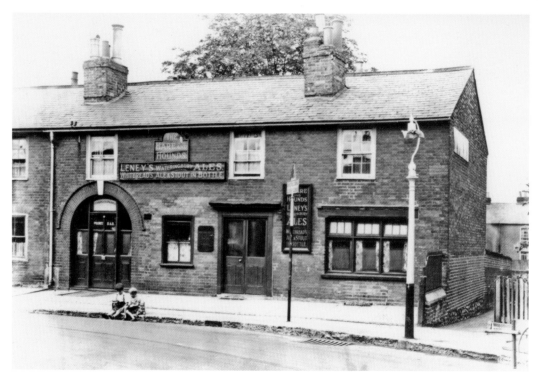

The Hare & Hounds

In the early 1900s the Hare & Hounds in Lower Boxley Road was tied to Frederick Leney's Brewery in Wateringbury. Being near the barracks it was always popular with the armed forces. In 1975 an IRA bomb exploded under a parked car causing several injuries and severely damaging the public house. The Hare & Hounds was later rebuilt.

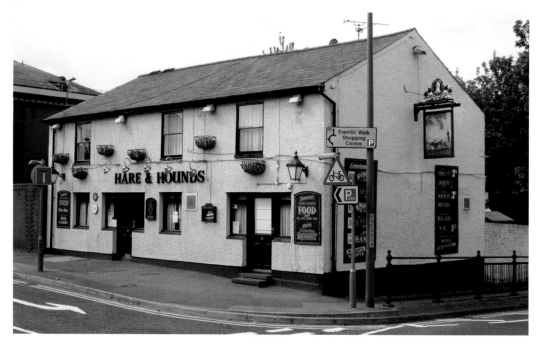

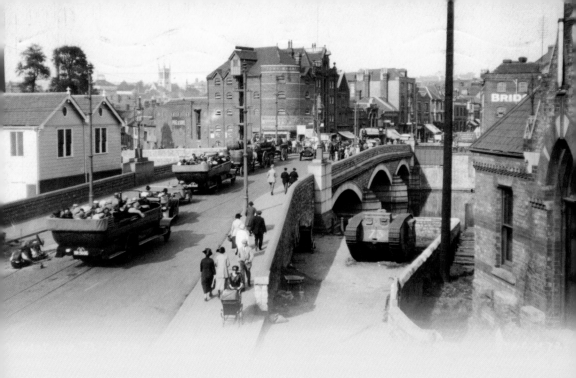

chapter 7

Bridges Over The Medway

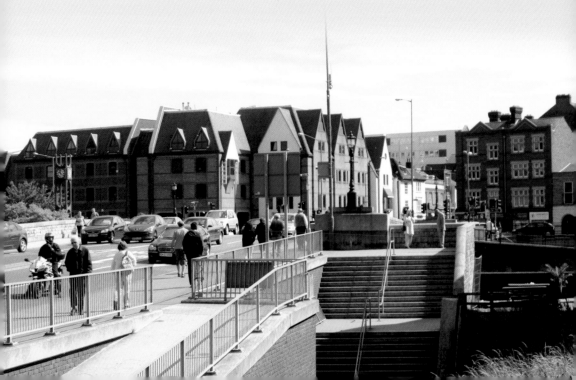

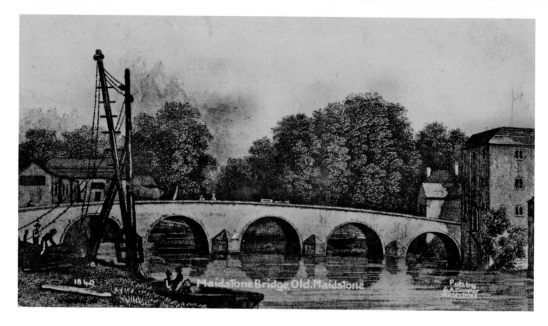

Maidstone Bridge

Maidstone's first stone bridge, presumably built for the Archbishops in the fourteenth century, originally had nine arches that were later reduced to five. When the present bridge was opened in August 1879, the two bridges spanned the Medway together, only a few inches apart. The old bridge was demolished in late 1879.

Today Maidstone Bridge is dominated by the Law Courts, opened by the Queen on 31 October 1984. Alongside is the Ferryman Inn (now the River bar), built to resemble a group of Kentish oast houses.

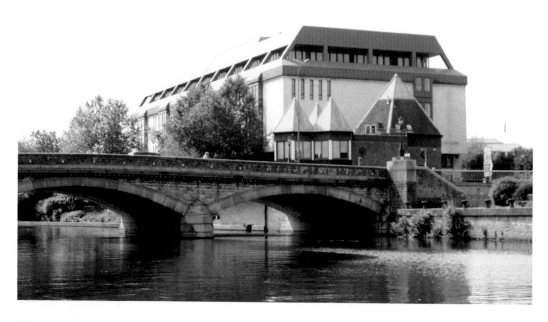

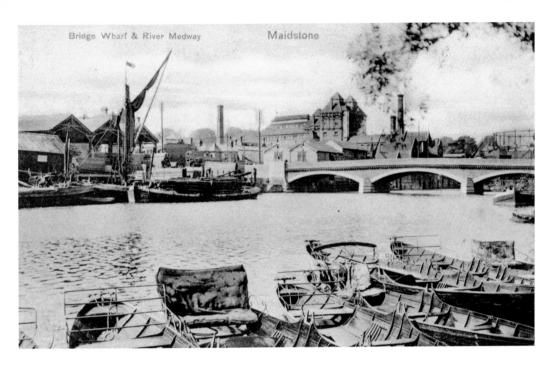

Bridge Wharf

Maidstone Bridge was widened in 1927 to carry another lane of traffic and the tank that had stood by the bridge since 1919 (see page 71) was transferred to Brenchley Gardens. Smythe's wood yard, the Medway Brewery, Canal Wharf and the gas works can be seen in the background. Now this bank has been cleared and a massive hotel and store are being erected. Rowing boats in the foreground were then a popular pastime. *The Kentish Lady*, a passenger boat, is moored this side of the bridge in the modern view.

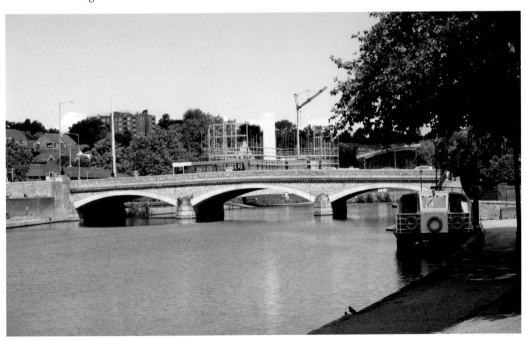

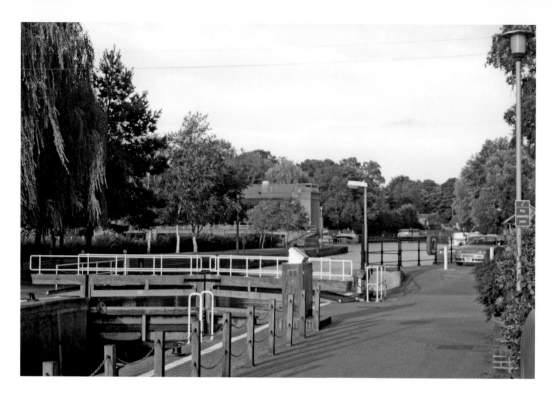

Allington Lock

There had only been a ford at Allington until the first lock was opened in 1792, when it became the highest point on the River Medway to be tidal. In August 1937 new tidal sluices costing £18, 000 were built to alleviate the flood problem upstream. The new sluices enabled a footpath to cross the Medway.

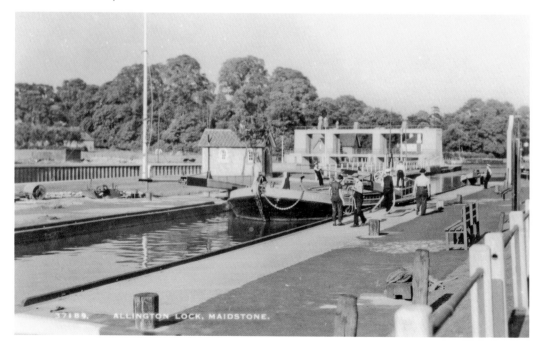

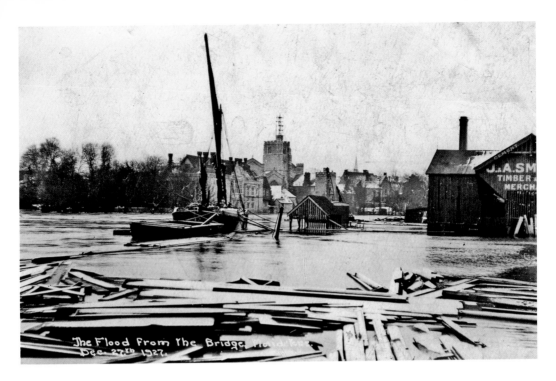

The Flood from the Bridge Maidstone Dec. 27th 1927.

Flooding on the Medway

The Medway rose eleven feet three inches above normal in the Christmas 1927 flood. Timber floated away from J. A. Smythe's wood yard at Bridge Wharf and Maidstone's damage amounted to thousands of pounds. Flooding was greatly reduced by the sluices at Allington Lock but, as shown below, it was still a problem in December 1979. Since the £3 million flood barrier near Tonbridge came into operation in 1981, floods have been much less disastrous.

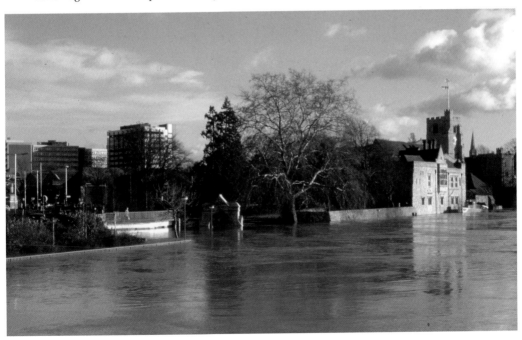

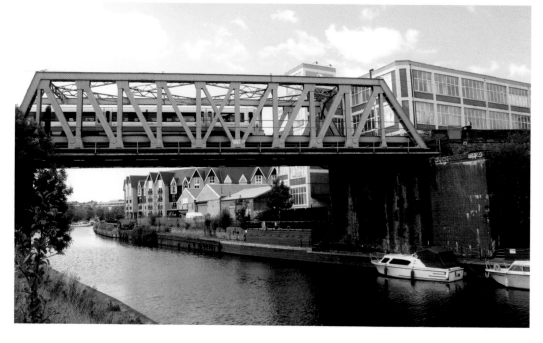

Maidstone High Level Railway Bridge

The present day High Level Bridge over the Medway was reinforced in the twentieth century to take heavier loads. The industries and barges have long since disappeared from the riverside. The earlier bridge was erected in 1874 for the former London, Chatham and Dover Railway system.

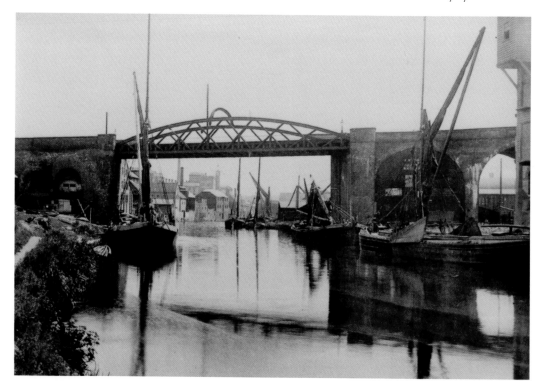

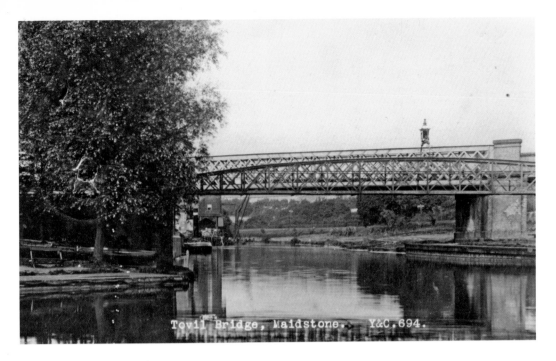

Tovil Bridge, Maidstone. Y&C.694.

Tovil Footbridge and Railway Bridge, 1910

The footbridge was built in 1871, to give access to the paper mills at Tovil. In 1886 the South Eastern Railway Company constructed an iron bridge that carried a short branch line to a goods station at Tovil. As road transport took over the goods station was closed in 1977. The rail bridge was demolished in 1986 but the iron footbridge has survived. The modern view, taken in the opposite direction, shows the remains of the rail bridge on the left.

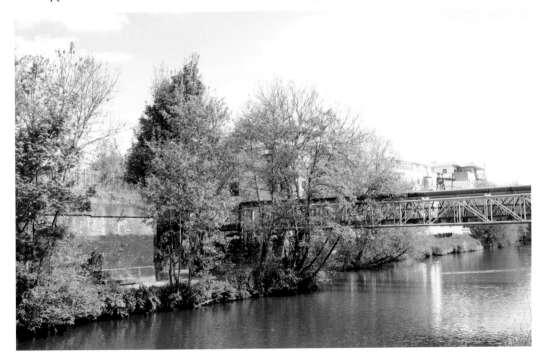

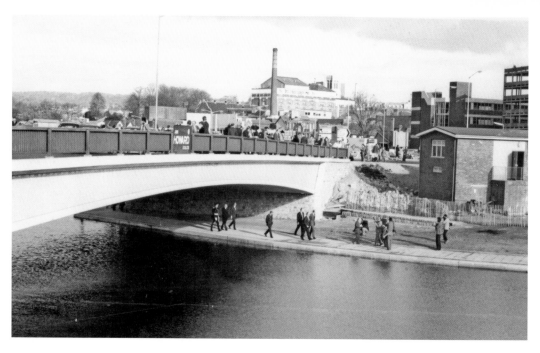

St Peter's Bridge

Maidstone's second road bridge over the Medway, St Peter's Bridge was opened by the Duke of Kent in November 1978. Fremlin's Brewery can be seen in the centre background and Medway Street multi-storey car park is on the far right. Fremlin Walk shopping centre has now superseded the brewery and the multi-storey car park has been demolished.

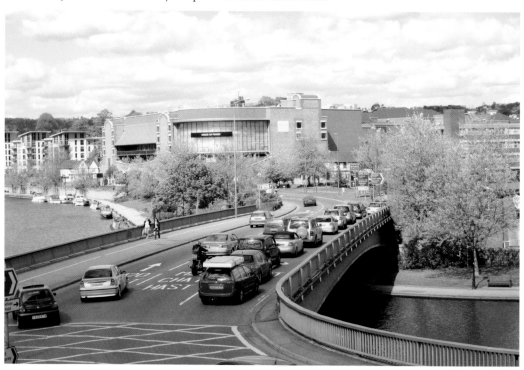

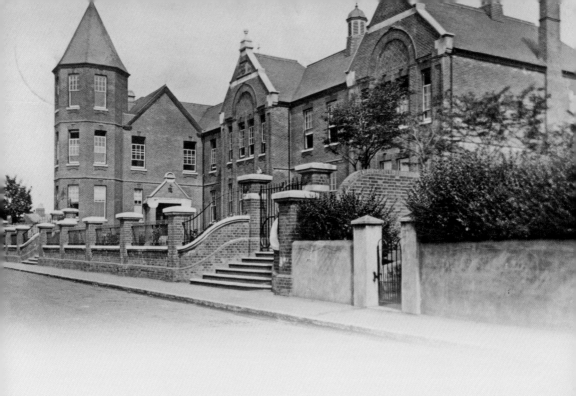

chapter 8

Schools and Hospitals

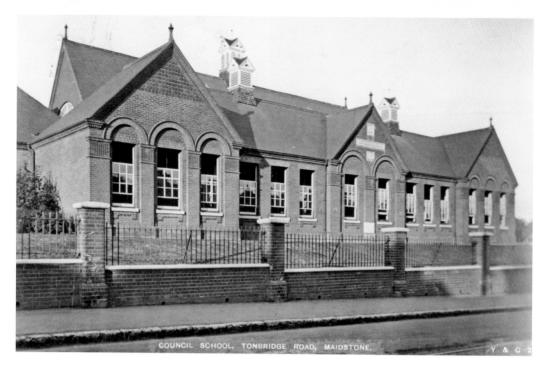

COUNCIL SCHOOL, TONBRIDGE ROAD, MAIDSTONE.

Tonbridge Road School

Erected in 1907 and later known as Westborough School, Tonbridge Road School was the first council school to be built in Maidstone. An infant wing was added in 1913 and, in 1927, the school was enlarged. In 1980 the school was relocated and houses have since been built on the site.

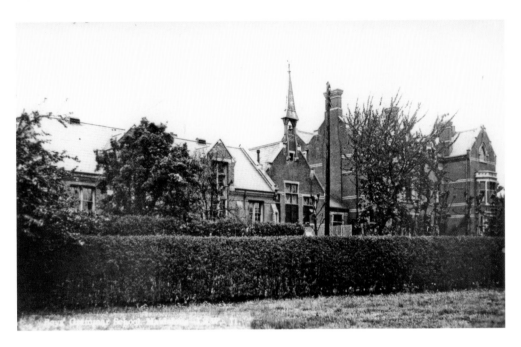

Maidstone Grammar School, Tonbridge Road, 1916
This school, opened in 1871, took the boys from the old Corpus Christi Hall in Earl Street. By 1920 the premises in Tonbridge Road became inadequate and a new school was built in Barton Road. The Tonbridge Road building later became the Boy's Technical School and has since been demolished.

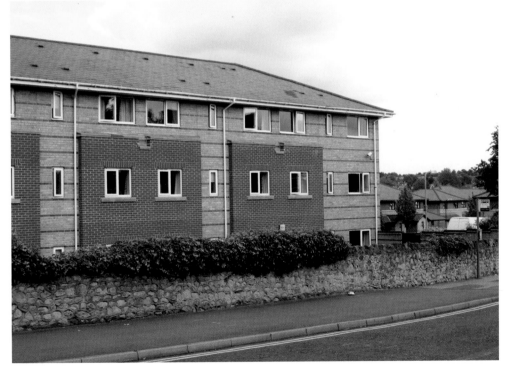

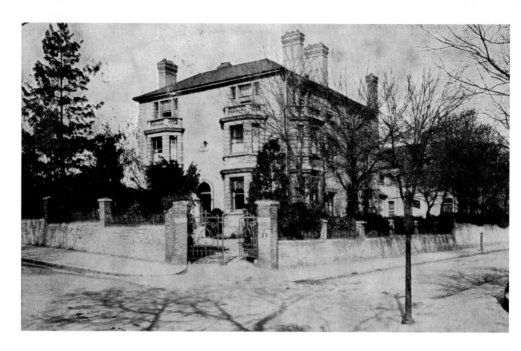

Brunswick House School, 1905

This school was established in 1860 on the corner of Buckland Hill and Buckland Road and for many years was the junior department of the Maidstone Grammar School. Recently a block of flats was built on this corner. Brunswick House School, now a primary school, has been relocated to the edge of the school's playing field with its frontage facing Leafy Lane.

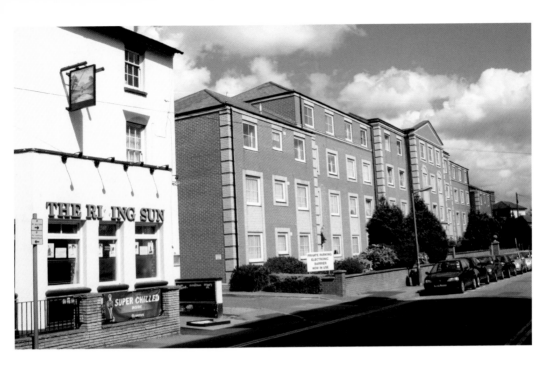

The West Kent Hospital

Hengist Court replaced the West Kent Hospital building in Marsham Street when the new Maidstone General Hospital in Hermitage Lane was opened in 1983. The original West Kent Hospital was built in 1832 by John Whichcord Senior. When first opened the building was lit by candles and the drinking water came from a well in the grounds. By the 1920s the hospital had been enlarged many times.

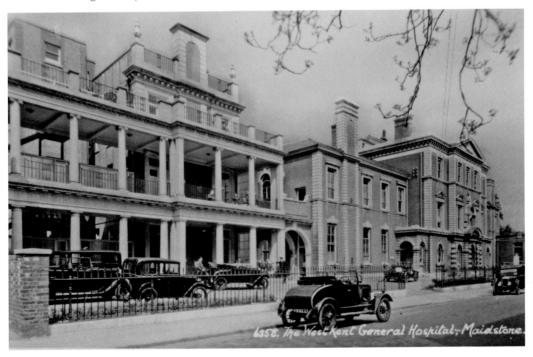

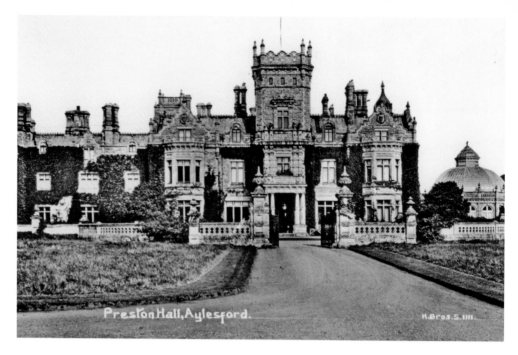

Preston Hall

Built in 1850 on the western outskirts of Maidstone, Preston Hall was reckoned at that time to be one of the greatest showplaces in the vicinity. It was built for Edward Betts, the partner of Sir Samuel Peto who erected Nelson's Column. During the First World War the Red Cross used Preston Hall as a convalescent home for soldiers and by 1925 British Legion Industries was formed to administer the estate. In 1946 Preston Hall became one of Maidstone's major hospitals.

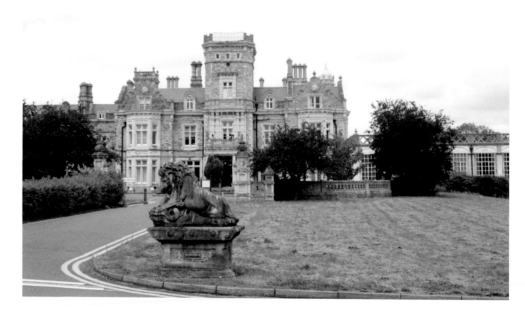

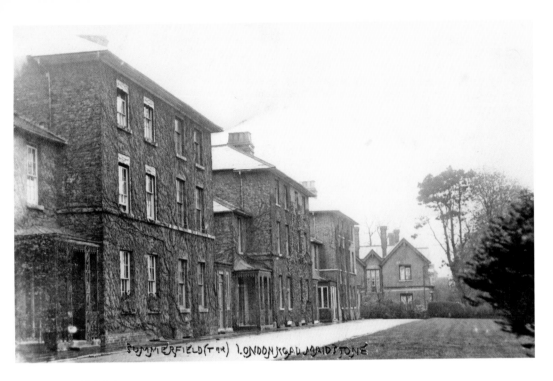

Somerfield Terrace

Built on London Road, near the corner of Queen's Road, in the early years of the nineteenth century, Somerfield Terrace is an elegant row of eight houses. They were specially erected for the Cavalry Officers at the barracks in Sandling Road. In recent years these houses became vacant and were taken over by Somerfield Hospital.

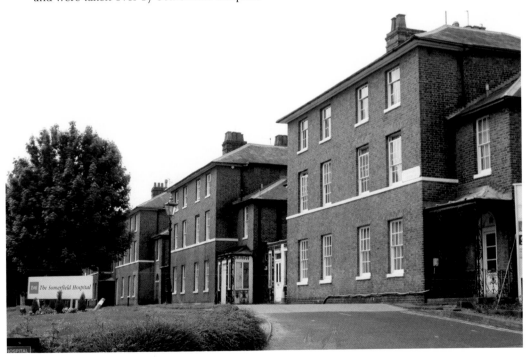

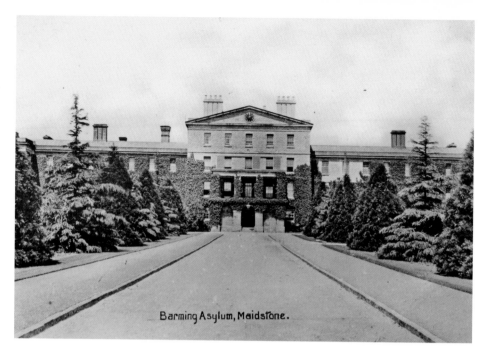

Barming Asylum, Maidstone.

Barming Asylum, 1909

The asylum first opened in 1833 to accommodate 174 patients. The authorities acquired further acreage in the vicinity and built another asylum in 1864, and a third between 1867 and 1872. The institution, latterly known as Oakwood Hospital, closed in the 1980s and has been converted to residential use. Maidstone General Hospital is built on the northern edge of the site.

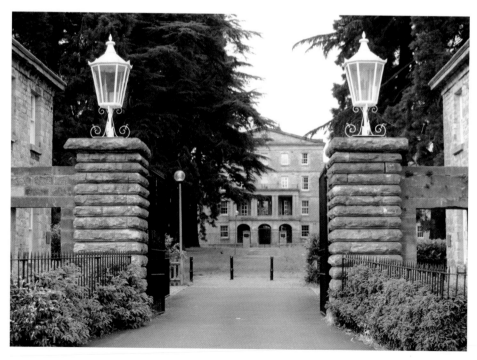

chapter 9

Architecture

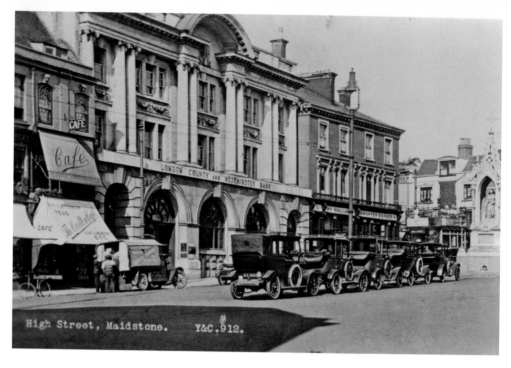

High Street, Maidstone. Y&C.912.

Buildings Along the High Street

This postcard shows taxis and a tram waiting in the High Street in the 1920s. In the background from the left are the Carlton Café, the London County and Westminster Bank and the Red Lion Hotel on the corner of Week Street. The bank is now the National Westminster Bank (NatWest), and HSBC Bank has replaced the Red Lion.

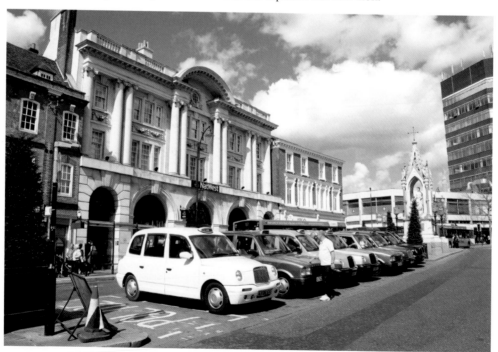

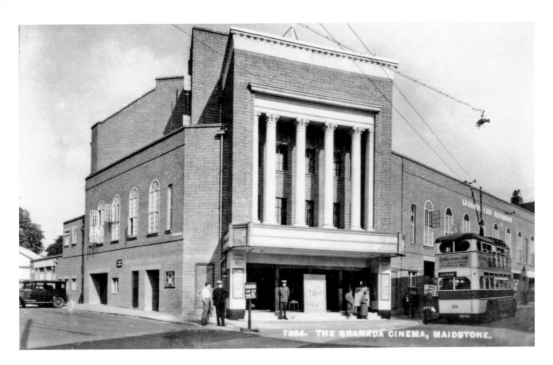

The Granada Cinema, Lower Stone Street, 1934

This photograph of the cinema was taken shortly after it opened. Note the trolleybus on the way to Loose. At that time there were four other cinemas in Maidstone: the Regal, the Palace, the Ritz and the ABC. In 1968 floods caused extensive damage to the Granada's stalls and it was closed. It reopened in 1971, completely modernised with a bingo hall on the ground floor and two luxury cinemas upstairs. The cinemas closed in 1999, but the bingo hall, renamed Gala Bingo has remained.

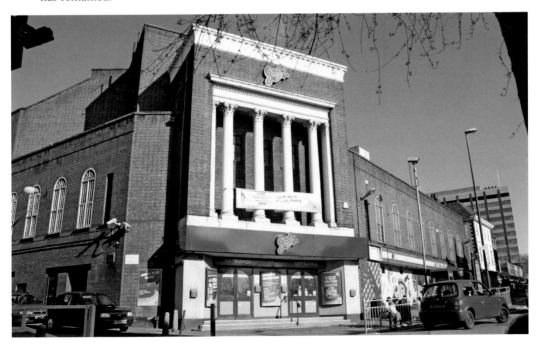

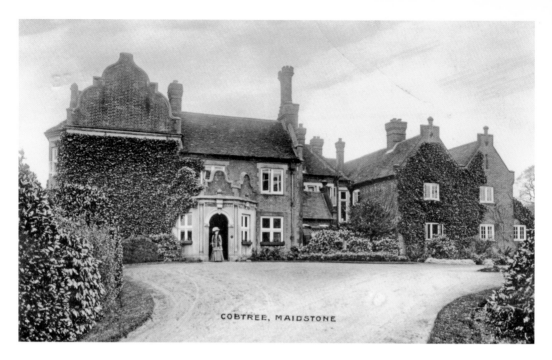

COBTREE, MAIDSTONE

The Cobtree Estate

Famous for Dickens' 'Dingley Dell', the Cobtree Estate was owned by Sir Garrard Tyrwhitt-Drake in 1908. In 1934 he set up a permanent zoo at Cobtree that lasted until 1959. When Sir Garrard died in 1964 the house remained with the family but he bequeathed Cobtree Park for 'the benefit of the inhabitants of Maidstone'. Since then, a golf course, the Kent Life attraction and a country park have been created on the estate. All that remains of the zoo is the restored elephant house, once the 'home' of Gert and Daisy, Sir Garrard's Burmese Elephants.

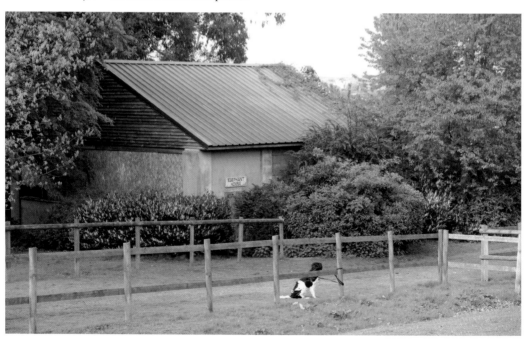

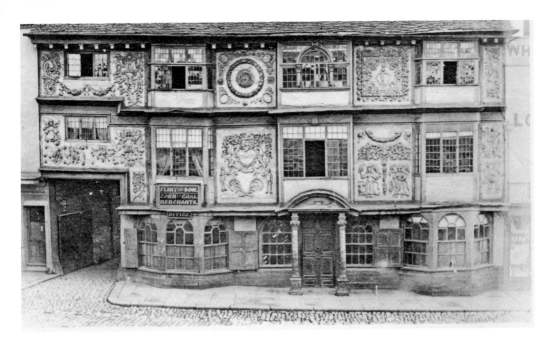

Astley House

This auspicious building in the lower High Street, known as Astley or Bliss House, was erected in 1587. It was pulled down in 1871 to make way for Maidstone's main post office. The pargetted panels were carefully removed to store in the museum but they disintegrated before arrival. The post office remained in the building at 58 High Street until 1928, when it moved to King Street. The premises are now occupied by a finance company.

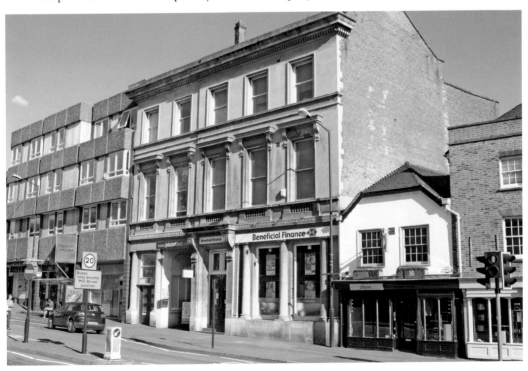

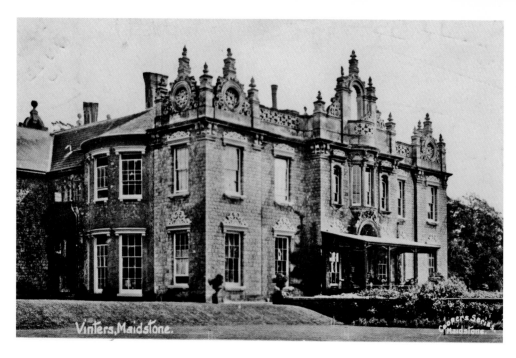

Vinters

Photographed here in 1910, Vinters was the home of the Vinters family in 1343. By the eighteenth century the estate belonged to James Whatman, a paper maker at Turkey Mill. In 1843 a descendant of James added the Jacobean front. Vinters Estate was sold in 1952 to the Kent County Council and the house was subsequently pulled down. A housing estate, a crematorium and television studios are now in the grounds. The rest is a nature reserve, but part of Vinters' terrace, the icehouse and the ha-ha has remained.

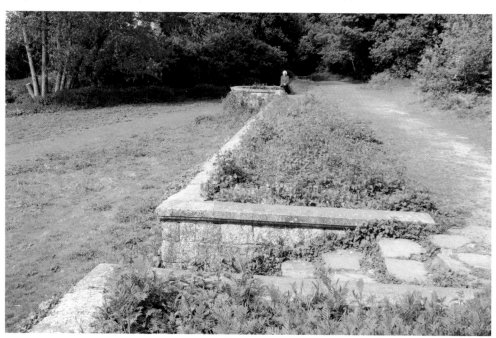

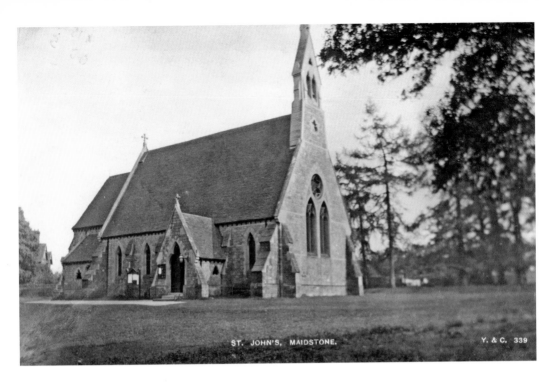

ST. JOHN'S, MAIDSTONE. Y. & C. 339

St John's Church

At the beginning of the nineteenth century Maidstone only had one established church, All Saints', but as the century progressed the population increased rapidly and further churches were needed. Between 1824 and 1897 nine churches were erected. One of these was St John's church, built in Mote Park in 1860. By the 1970s diminishing numbers of worshippers had made the church unviable and St John's became known as Cobtree Hall, a centre for the handicapped.

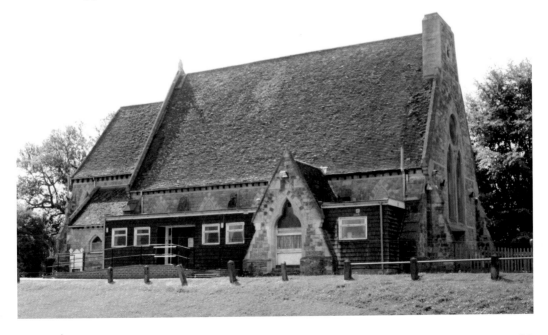

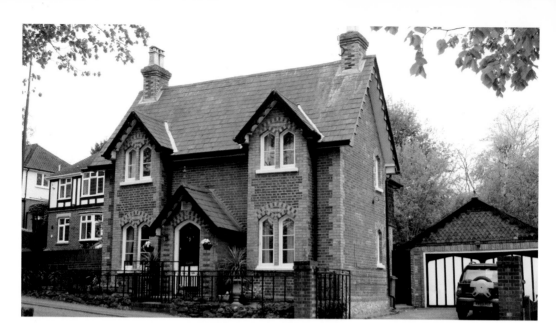

Heathfield

Overlooking Penenden Heath was the extensive premises of Heathfield, the home of Ralph Fremlin. This view shows the lodge that would have accommodated some of his staff. Two elephants (Fremlin's Trademark) can still be seen in the front door glass panels. The main house had its entrance in Heathfield Road (known locally as Fremlin's Lane for many years.) After Ralph died, Heathfield became a Dr Barnardo's Home. It was demolished in 1983 to make way for a housing development.

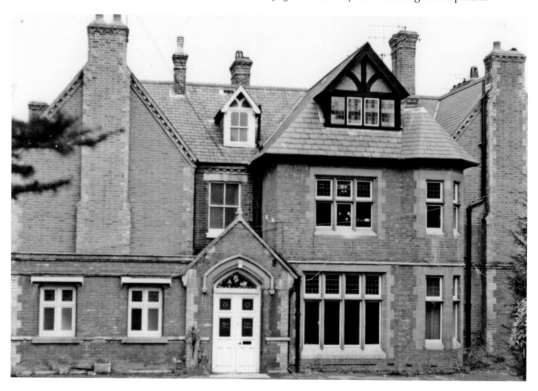

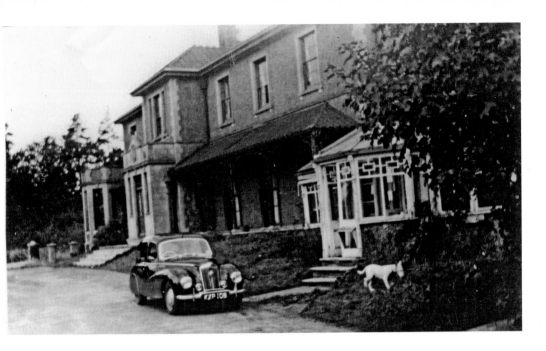

Foley House, 1956

In 1824 William Tyssen, High Sheriff of Kent, purchased part of Penenden Heath for £1,700 and built the Foley Estate on the site. Included were lodges, stables and a coach house. Gallows Hill, where criminals used to be executed, was within the grounds. The estate was later occupied by Alexander Randall. Randall presented Queen Victoria's Monument to the town in 1862. Foley House, like so many others, was pulled down in the 1960s and town houses in Saxon Drive have taken its place. Below is Foley Lodge (now called The Lodge), still in existence on Sittingbourne Road.

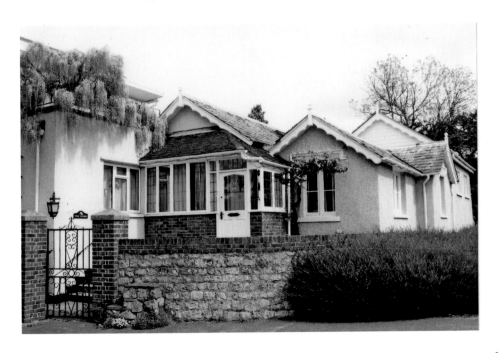

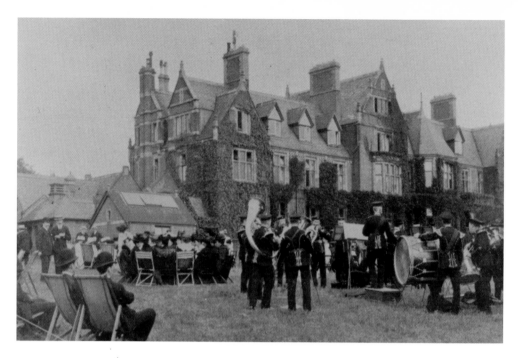

Springfield Paper Mill

The centenary celebrations at Springfield in 1907. Springfield Paper Mill was founded by William Balston in1807 and was the first in the country to be powered by steam. Springfield was purchased by Kent County Council in 1921 and used as offices. Since then a library and a tower block, known as the book stack, were added. Springfield House has remained but a housing development has recently been built in the grounds.

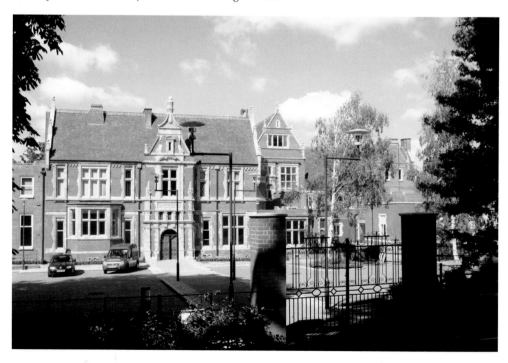